PATRICK T. TUCKER

Riding
the
High Country

Edited by
Grace Stone Coates

FJORD PRESS

SEATTLE

1987

Published and distributed by
Fjord Press
P.O. Box 16501
Seattle, Washington 98116
(206) 625-9363

Originally published by The Caxton Printers in 1933

Thanks to the Seattle Public Library for preserving this book

Fjord Press recognizes that some of the attitudes of the author
may offend the sensibilities of today's readers, but we have
refrained from any alteration of the text in order to preserve
the author's authentic cowboy lingo of the 1880s.

Design & typography: Fjord Press Typography, Seattle
Cover design: Art Chantry Design, Seattle
Cover illustration:
C. M. Russell, "Bronco Busting" (detail), watercolor, 1895
Amon Carter Museum, Fort Worth

Library of Congress Cataloging-in-Publication Data:

Tucker, Patrick T., b. 1854.
Riding the High Country / Patrick T. Tucker ;
edited by Grace Stone Coates. — 1st ed.
p. cm.
Originally printed: 1933.
ISBN 0-940242-33-8 (alk. paper) : $17.95.
ISBN 0-940242-32-x (pbk. : alk. paper) : $8.95
1. Russell, Charles M. (Charles Marion), 1864–1926.
2. Artists – Montana — Biography. 3. Tucker, Patrick T., b. 1854.
4. Cowboys–Montana — Biography. 5. Montana — Biography.
I. Coates, Grace Stone, 1881–1976.
N6537.R88T83 1987 709'.2'4 — dc 19 [B]
87-27562

Printed in the United States of America by Edwards Bros.
First edition, 1987

To all who remember
The Old Trails

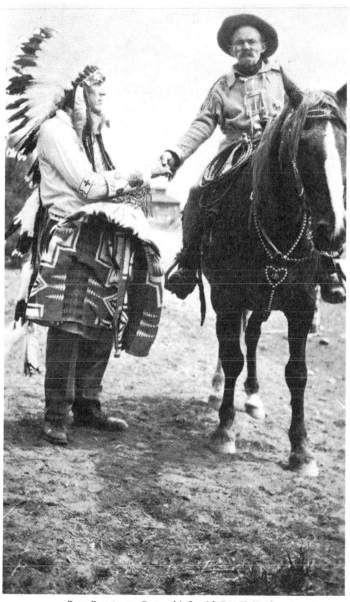

Sam Sampson, Crow chief, with Pat T. Tucker

Foreword
to the 1933 edition

N O O N E H A S challenged Patrick T. Tucker's claim that he is the oldest cowboy in Montana. There are men still living who were cowboys in Montana before Mr. Tucker arrived. There are men older than Mr. Tucker, miners, merchants or oil magnates, who were once cowboys. But Mr. Tucker is the oldest man, he believes, who has consistently retained the viewpoint and preoccupations of a cowboy.

Pat "Tommy" Tucker was born in 1854. He "forked his first hoss" when he was five years old, and has been "sitting leather" ever since.

He was ten years older than Charles M. Russell; and from the time he came in contact with Russell, a lad of seventeen "with a pilgrim smile on his boyish face," he was his friend and mentor. Their friendship lasted for life, and Tommy was one of those who followed the sad procession behind Russell's horse-drawn hearse and riderless pony.

A year before his death Russell had said: "Tuck, write your stories. Put them in a book, and I'll paint you twenty-five pictures for it and not charge you a cent." Tucker wrote the story — wrote it laboriously in longhand. He realized that the manuscript must be corrected and typed. Unfortunately, the typist entrusted with the work failed to appreciate the charm of Mr. Tucker's style. He missed in it the humor that had prompted Russell's offer. He "edited" the text into stilted and sophomoric English.

The manuscript was typed, and Tucker was relieved to have it off his hands. He was glad to be done with the haphazard, odd-sized sheets he had labored over. Into the fire they went. He took the typed manuscript to Charley Russell.

Russell read the first page, and leafed the book through, reading a sentence here and there. He handed it back, and with simplicity and directness like Tucker's own, said, "They've spoiled it, Tommy. Let me have the story the way you wrote it." Then Tommy told him the original manuscript had been destroyed. Patiently he went to work to rewrite the story, but within the year Russell was dead.

"Riding the High Country" is Tommy Tucker's story of his association with C. M. Russell during the cowboy artist's first years on the range. The story's value lies in the degree of its authenticity; its charm, in Mr. Tucker's simple, direct narrative. I have taken few liberties with his text. The story stands almost word

for word as he has written it. For the reader's ease I have formalized punctuation and spelling — an "eval sprat" is more readily recognizable as an "evil spirit." Aside from such conventionalization of form the story is Mr. Tucker's own.

It will not interest those who are looking for synthetic thrills. It is for those who are wakening to the fact that a significant culture of the West has gone. This was a womanless culture. The frontier West was a man's world. As Tommy puts it, there was no calico on the range — where do we find a woman in Russell's paintings?

The Indians are gone. Their culture, like the white man's that followed it, is gone. There are few alive who remember that life, not as it has been depicted, but as it was. There are fewer still who can tell what they remember. Pat Tucker is one of these few. He knows the cow country from the Rio Grande to Peace River. The blanket Crows counted him their friend. And there was between him and Charley Russell that loyalty which is more steadfast than the love of man for woman.

Grace Stone Coates

Mr. and Mrs. Pat Tucker
(from photograph taken on their wedding day)

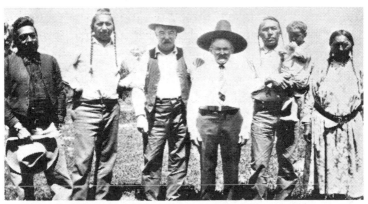

Reading from left to right: Squeaky Joe, George-Goes-Ahead, Tony Loftus,
Patrick Tucker, White Feather, Plenty Coups' sister, and her child

CONTENTS

C. M. RUSSELL
GREAT FALLS, MONTANA

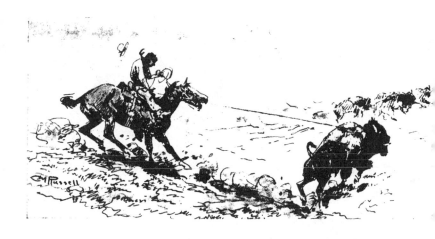

P T Tucker Oct 27 1921

 Friend Tommy I'm a long time answering
your letter but that dont mean I for gotten you You daughter came
to see me and I was glad to meet her and I want to thank her for
the photografs she sent among them was one of you and a bull that
bull was some size but hed look puny compared to the one you droped
your loop on thirty seven years ago If I rember right he got one
for foot through the loop and the branded lay in frond of his hump
and judging from the way he traveled you and Bunky wasent eavin
a good rough look he started for Texas like he didnt mean to make
many stops but you am Bunky didnt want to go that far so you
through of your dallyes and made him a present of your raw hide
Those were good old days Tom we were kids then the buffalo went
long ago the wild cows we knew and the cow hosses have joined them and
most of the cow punchers of our time have crossrd the big devide
we usto know every body but time has made us strangers
but we got no licence to kick we got the cream let these come latly
have the skim milk If ever I get down on your range Il
round you up and I want you to do the same
 with best whishes to you and your
 big fambly from me and my small one
 your friend C M Russell

C. M. RUSSELL
GREAT FALLS, MONTANA

Oct 27 1921

P T Tucker

 Friend Tommy I m a long time answering your letter but that dont mean I v forgotten you You daughter came to see me and I was glad to meet her and I want to thank her for the photografs she sent among them was one of you and a bull that bull was some size but he d look puny compared to the one you droped your loop on thirty seven years ago If I rember right he got one for foot through the loop and the hondue lay in front of his hump and judging from the way he traveled you and Bunky wasent eaven a good rough lock he started for Texas like he didnt mean to make many stops but you and Bunky dident want to go that far so you made him a present of your raw hide Those were good old days Tom we were kids then the buffalo went long ago the wild cows we knew and the cow hosses have joined them and most of the cow punchers of our time have crossed the big devide we usto know every body but time has made us strangers but we got no licence to kick we got the cream let these comlatlys have the skim milk If ever I get down on your range I l round you up and I want you to do the same

<div align="right">

with best wishes to you and your
big fambly from me and my small one
your friend C M Russell

</div>

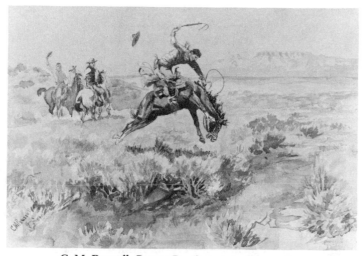

C. M. Russell, *Bronco Busting*, watercolor, 1895
Amon Carter Museum, Fort Worth

Riding
the
High Country

1

Ancient Enemies

ONE DAY IN October, 1878, I was sitting on top of Haystack Butte, Wyoming, in the shade of my cow hoss. The Sweetwater River bottoms had four thousand grazing longhorns that I had helped trail up from the Panhandle, Texas. I wasn't feeling bad, I was feeling good; my teeth were good, my appetite was good, and my buckskin shirt had all the buttons on. My eyes had never been snow-blind, so I began to look at what I could see around me.

Off to the west I could see the Big Horn Mountains. From their snow-covered peaks down to the foothills was a solid forest of virgin pine. The water that tumbled over the rocks from all the little creeks to make the Sweetwater came out of shady, timbered mountains; and when an old Texas steer stuck his nose into the ice-cold stream he would switch his tail to say it was good.

When I looked south I could see South Pass, where for centuries the Indians had trailed back and forth.

When I looked down on the Sweetwater I saw an emigrant bull team fording the river.

It was Indian summer. The leaves dropping in the clear blue water were golden, and cottonwoods on the river bank were beginning to look bare. In all the foothills were antelope, elk, and buffalo.

I thought about the dusty trail, the midnight cattle rustlers and Indian scares, and — what tried a nervy cowboy — a stampede on a stormy night. For fifteen years I had been sitting leather everywhere from Old Mexico to Alberta, ever since I forked my first hoss when I was five years old. The days had been filled with action. I had seen midnight stampedes when rain poured and lightning flashed and longhorns milled round and round, but we always had the whole herd when the clouds rolled by in the morning. When work was over we rode up to the camp fire, pulled the leather off the wet backs of our sweated ponies, and were at home under the sky.

So, while sitting there I made up my mind to quit the cows, and hit the trail for Montana.

I forked old Smoky hoss, and rode around the herd for the last time. Then Smoky and I galloped into camp. The camp was in a beautiful spot in the bend of the river, and I filled up on a good meal cooked over the camp fire. After the feed I let my belt out one hole, and felt okay. I walked up to old Jim Hightower and said, "Jim, I'm blowing for Montana. You have any silver ready for me in the morning?"

"All right, Tuck," he said. "You're heading for a good range."

The next morning I packed my fifteen-years' gath-
ering in my war bag, and rolled my bed. The night
wrangler drove the saddle ponies into the rope corral,
I caught my three hosses, packed my bed and war bag
on my Croppy hoss and hit the trail for Montana.

It was a nice sunny morning, October fourth. I
trailed east until noon, then camped on the old Indian
travois trail that ran from South Pass to the British
line. There was plenty of wood and water here, and all
kinds of game. I got to the Crow Indian camp on the
Yellowstone River, October 23, and camped with the
Crows for eight days. I traded my Paint cow hoss to
Little Bear, a subchief, for two good hunting ponies.

On November ninth I got to the Gap in the Judith
Basin, Montana.

At the east end of the Gap was a new-built log cabin
eighty feet long, a good log barn, and a large round
corral built of pine poles. All the buildings were in a
well-sheltered spot at the foot of the Belt Mountains.
Ice-cold water ran down by the side of the house from
a bubbling spring, and a small ditch took it to the barn
and corral.

This was a busy place. When I trailed up, a man
dressed in buckskin was standing at the barn door. He
was the barn boss, Red Mulby. I had known Red be-
fore, down south. He was an old tender for the Wells,
Fargo Stage Company. He told me Stevens wanted
somebody to hunt wild meat for his boarding house,
and said he would take me inside to talk to him. The
first door we came to led to the barroom. Al Stevens
was behind the bar dishing out red ink at four bits a

drink. The barroom was full of freighters, trappers, and prospectors, all feeling good and on their good behavior.

Red and I ordered drinks, and then Red spoke for me: "Mr. Stevens, here is a boy from the South, and he will sure furnish your camp with plenty of meat."

We took our drink, then I shook hands with Mr. Stevens, and he gave me a job for the winter getting fresh meat for the Chinese cook. There was a big gang to cook for, with people coming and going every day. Here at the Gap I met Harvey Mains, a trapper and hunter famous in the Northwest. He was an old, white-headed man, tall, and muscled up like a race hoss, straight as an arrow, with piercing black eyes. He had trapped and hunted in the Rocky Mountains from the Rio Grande to Peace River in Canada. He told me where to go for game.

On November 15 I got ready to make the big hunt. Al Stevens let me have a good Sibley tent, and I packed the two hunting ponies I had got from Little Bear. The foothills and jack pines were covered with snow, just right for hunting. I broke trail for three miles. It took steep climbing to get up where the mountain sheep ranged. Sheep made the choicest meat.

Trailing through the soft snow, I came to a spring in a small open park, and made my camp here close to two big spruce trees. I cut green pine boughs and made a good bed, built a camp fire and cooked dinner, and after dinner lay down and slept until four o'clock. Then I got up, saddled Old Guts — one of the

ponies I got from Little Bear — cleaned my buffalo gun, and slipped on to this Indian hoss. We trailed through tall pines into another open park, and there, under a big cliff, were thirty mountain sheep, some standing, some lying down. A big buck out on a rock was close herding his band.

I slipped off my pony, sneaked through the timber until I was close enough for a shot, and got this buck first. I shot five more sheep while they were milling around in the deep snow. The next day Al Stevens' boarders had plenty of fresh meat. I packed all of it in to the stage station.

It was no trouble to get fresh meat in the Belt Mountains in those days — elk, blacktail deer, or sheep. There was no law and no limit, yet no meat was wasted. It all went into camp. What little refuse we left behind, a wolf or coyote soon cleaned up.

Hunting was my job. November 29, I ran into a band of fat elk high up in an open park. When I stopped shooting, thirteen elk were down, and they all had fat on their ribs. I cut up the meat and piled it, ready to be packed out, and hung an old blanket on a tree close by to keep lions and grey wolves away from it. Two days later I was back with my four hosses, ready to take in the meat. All at once the four hosses pricked up their ears and looked off toward the south. You can't fool a hoss, so I quit packing meat, and looked toward the south, too.

Sure enough, way off, coming through a bunch of jack pines was a band of Indian ponies with Indians driving them. The Indians trailed right to my hunting

camp and cleaned it out, leaving my old Sibley tent grubless. I leaned against my pack hoss and watched those thieving Indians pack my bed and grub on their ponies, and trail north. It was a good thing my four hosses were with me, or the Indians would have left me afoot. I finished packing my other hosses, and started down the trail I had made coming up. Halfway down the ponies saw something again. More Indians were coming. They were headed straight for my camp, on the trail the thieves had followed. As I came closer I saw they were Crow Indians in full war paint. They got to my camp just as I did, Little Bear and sixteen Crow braves.

Little Bear told me the Indians who had robbed my camp were a party of Piegans. They had stolen a bunch of Crow ponies, and the Crows were after them.

"You come. We get bed, grub. You come, we catch him quick," Little Bear said. It was then about noon.

I didn't have war paint on, but I was sure on the prod. I told Little Bear I would go with him. I told him I had a good hoss, and I'd ride round the hoss thieves and head them off by taking a few long shots at them.

We took the thieves' trail. Smoky was a real hoss, and he took the lead in a long, swinging lope.

The Piegans had gone down a dry canyon. As we rode to the rimrock we could see them two miles below. I told Little Bear to have his men rest their ponies awhile, and give me a chance to ride around and head the Piegans off. I fell back, circling the

rimrock, and dropped down on Antelope Creek just in time to make the mouth of the dry canyon.

Old Smoky saw the Indians. A French breed and a Piegan were in the lead, breaking trail for the stolen ponies. They saw me, you bet, so Smoky and I got behind a boulder to make a long shot. It dropped short, but it had the right effect. The Indians stopped in their tracks, and bunched up to have the big powwow.

The Piegans stopped, but the Crows didn't quit coming. They raced down the dry canyon shooting as they ran, and emptied two Piegan saddles. The uproar of whooping and yelling was terrific. The Piegans fired a few shots, but they were short of ammunition. Since the Piegans were giving all their attention to the Crows, I rode up to within a hundred yards. The Indians were fighting it to a finish, hand to hand, with butcher knives and tomahawks. The noise chilled my blood. The Crows were all picked warriors, and the Piegans were no match for those braves. Both sides used long knives and tomahawks, and the fight was bloody. Here and there I saw men I knew.

Little Bear and French Joe were singled out fighting by themselves. Each would make a rush with his war hoss, back off, and rush again. Their fight lasted a long time, but Little Bear had the best hoss. At last the Crow's hoss made a leap into the air, and when he hit the ground Little Bear's knife was in the half-breed's belly. The breed rolled off his hoss with the knife still in his body. Little Bear slipped off his hoss, easy, and sunk his tomahawk in French Joe's skull.

The Crow chief straightened up, then, and looked around. The fight was over.

I rode up. It was growing bitter cold.

The Crows by this time had gathered around one of their braves who lay dying in the snow, the blood oozing from his breast where he had been struck with a tomahawk. When he was dead Little Bear made a sign, and the Crows pulled their knives and began cutting the foretops of the dead Piegan hoss thieves. The blood was still dripping from the wounded Crows and dead Piegans.

The battle had been fought in a small circle. The snow was trampled hard on the frozen ground, and steam was blowing off the pools of blood still gathering from the bodies.

When all the scalps were taken, the Crows had a medicine talk. As soon as this was over Little Bear walked over to me and said, "Crow squaw come soon. Fix all boy up make good fight."

Little Bear could speak a little English, not much. He said, "When all fix up, go back hunting camp."

The stolen ponies were standing on a sidehill in a box canyon, looking up the draw. Sure enough, here came the Crow squaws, their ponies on a slow trot. They had extra blankets and robes for the fighting men, and some grub. They slid off their ponies, got out their little buckskin sacks of medicines, and went to work checking the bleeding of the braves' wounds. One young woman knelt by the dead Indian. He was her sweetheart, and the look on her face would have taken tears from a rock.

When the Indians went into action they were well wrapped in blankets, but as they fought the blankets kept dropping off and were scattered everywhere on the battlefield. As the women worked with the wounded, the braves gathered these blankets up. The dead Indian was lifted on to his pinto hoss, and the young squaw put her arms around him and walked beside him, holding the body on. The Crows hit the trail for my camp, while I came on behind driving the loose ponies. The trail was sprinkled with blood, for the Indians and some of their hosses were pretty badly cut up.

We reached camp about dark. The Crow squaws put up wikiups and built a fire. The old squaws kept on doctoring the wounded braves. We had plenty of fresh meat at my camp, now, and the flour and bacon and coffee the thieving Piegans had stolen, and we had packed back.

The Crows stayed with me five days. They made a travois out of poles, lashed buffalo hides to them, and placed the dead warrior on it. The fifth day they shook hands with me, and all started for the Crow camp across the Yellowstone River.

I went to the dry canyon weeks later. Wolves and coyotes had eaten the flesh from the Piegans' bones, and scattered them everywhere. Skulls and bones of horses and Indians lay around this coulee for a year.

The next fall after the fight, when I was trailing from Oka to Yogo with my three ponies, I picked my way down Antelope Creek to the old battle ground. The bones were scattered and bleaching. I slipped off

the leather, took the packs from my ponies, and hobbled my hoss White Bird. Croppy and Dinky, my pack hosses, would stay wherever my white hoss stayed. There was wood and water handy, so I camped two days looking over the old fighting ground and remembering what I'd seen. The third day I hit the trail for the Judith River, and as I came near it I saw smoke rising from the willow brush. Coming closer, I saw Indian ponies along the river bottom, and an Indian camp in the brush. The Indians were Piegans looking for the hoss rustlers that the Crows had killed the fall before. I told them their friends were all asleep over on Antelope — the Crows had got their scalps. They must have gone over there and gathered up the bones and taken them away, for the next time I went there no bones were in sight, not one.

2

New Friends

THE SHARP BARK of a coyote woke me. I had been dreaming of my boyhood days on the Rio Grande. The morning star was looking over the white peaks of the Snowy Mountains, and the dark blue sky was studded with stars.

I did not get up. I lay under my buffalo robe. Over me were two Navaho blankets, with a canvas on top of them and another canvas under the robe. My war bag and saddle were my pillow. I could hear the water ripple as it worked its way around the moss on the boulders bedded in the gravel banks of the Judith River, and feel the wind in my hair. A brisk, cool wind in the morning always gave me a good appetite. I lay in my bed in peace and happiness, and waited for day to break. Stars were paling fast, and as soon as the sun began to make the sky red I got right up and rolled my bed.

My saddle hoss was close by, pulling on the rawhide rope tied to my saddle horn. When I got my bed

rolled he came up to me and began to paw the long grass. That meant he wanted water.

This little hoss was foaled down on the Rio Grande. When I found him I was riding through the Texas sagebrush on a swinging lope. All at once my hoss Grey Eagle stopped short and bowed his neck. His ears went straight up. In front of us in the sagebrush lay what I thought was a dead sheep. As I spurred Grey Eagle closer I saw it was a baby hoss, pure white. The poor little fellow began trying to get up. His young mammy had gone off and left him there to die. I got off my hoss and lifted this hungry colt to his feet. He bowed his little neck and began to whinny. He smelled of Grey Eagle and thought he was his mammy.

I am hard-hearted, but I love a hoss, young or old. I put young White Bird on my saddle, got on behind him, and trailed to the home ranch at the mouth of the Pecos River. He had been with me ever since.

I didn't have to sleep out here in the grass where White Bird was pawing for water. This was the home ranch of the Iowa Cattle Company, and within sight of me there was a good log shack, a log barn, and a big pole hoss corral. In this corral were eighty-six head of saddle hosses that I had trailed in from Oregon. I drove them into the corral at night, and close herded them in the daytime, for they were on new range and I had to watch them to keep them from taking the back trail. They were first class cow hosses. These ponies had different complexions. Some were black, some buckskins, and some pintos. I opened the big gate of the round corral, and the hosses trailed down

to the river and drank. Then the old bell mare took the lead, and the band trailed up the sidehill where the bunch grass was short and tender.

White Bird had filled up on the long green grass that grew along the river bank, and was switching his tail as he walked to the cabin door for his lump of brown sugar. He was a real camp hoss. When he had eaten his sugar he trailed down to the river, filled up on water again, and went to stand in the willow brush with his head sticking out. He wanted to see the hosses that were grazing on the sidehill, and look up and down the river.

By this time I was getting empty. I caught a few grasshoppers, took my willow fish pole, and in a few minutes had enough speckled trout for breakfast. There was a good fireplace in the log shack. I had two long-handled frying pans, so I mixed some sourdough flapjacks to cook while the fish sizzled in the bacon grease. Canned butter, black 'lasses, hot flapjacks, fresh trout — these washed down with good old Java!

After these I took my morning smoke.

My saddle needed new strings. While I sat putting them on, White Bird kept looking up the river. Pretty soon I saw a rider coming slow and easy down the river bottom. He was too far away for me to tell whether or not he was an Indian. As he came nearer I could see he was riding a small pinto hoss, and when he got close I saw he was a young boy. He spurred his pinto pony right up to where I was sitting on the grass putting the new buckskin strings on my saddle.

His outfit was all wrong. His boots were too big. One stirrup was longer than the other. His las' rope was sea grass. It was not coiled right. He had on his head a cheap wool wide-brimmed, low-crowned hat. His bridle and saddle were a mail-order outfit. He had dark blue, fiery eyes, and a satisfied smile on his face. The peach velvet showed on his pilgrim cheeks.

I said, "Get off your hoss, and camp for a while."

He got off slow and easy, the way he rode, and looked bashful. But as he sat on the grass he looked satisfied, as if he had found what he was looking for. My outfit tallied up with what he wanted to see.

I asked him his name.

"Charley Russell."

I said, "Shake hands with a real cowboy."

His hand was soft. I asked where he was from.

"St. Louis."

"You're a long way off your range. What you aiming to do in Montana?"

"I want to be woolly."

I looked at him and laughed. He didn't seem to like my laughing at him.

"Did you ride your pinto pony all the way from St. Louis?"

"I came up the Missouri River. I came on a steamboat." [1]

[1] Charles M. Russell came from St. Louis over the Union Pacific and Utah Northern railroads, and by stage to Helena, making the trip in company with Willis "Pike" Miller in 1880, before he was yet fifteen years old. He may have told the amiably derisive, inquiring cowboy stranger whatever it popped into his head to say; and subsequent correction either happened never to have been made, or faded from Mr. Tucker's memory, while the original impression remained vivid.

He sat looking at my saddle, never taking his eyes from it.

"Your saddle is bigger than mine," he said. "How much did you have to pay for a saddle like that?"

"Sixty dollars. How much did you pay for yours?"

"My mother gave me thirteen dollars to get a saddle, bridle, and lasso rope."

I laughed again. I could see he didn't like it.

"Did you ever catch anything with your new las' rope?"

"I can't lasso, but I'd like to learn."

I told him it took a long time to learn to rope. When I had finished fixing my saddle strings I put the saddle on White Bird, and told Charley I must ride out to look after the hoss herd. He said he'd like to see the hosses. I told him he could have one of my saddles while he stayed in camp. I had to make the stirrups longer for him, for he was taller than I. We rode out to the sidehill, rounded up the hoss herd, and trailed them back to the corral. When they were inside I got a rope, and threw a loop on my Bunky hoss. I was beginning to like Charley Russell. He told me he liked to ride a cow hoss.

"Bunky is my top hoss," I said.

"What is a top hoss?"

"A good rope hoss. You can go into a herd with a top hoss, and he will cut out any longhorn you want. When you're through, throw the bridle reins over his head and tie him to the ground. No good cow hoss will go far if you tie him to the ground — he doesn't like to step on his bridle reins. It hurts his mouth."

Russell wanted to know about all these things. If he

had been a smart guy I would have told him nothing.

We rode around the hills until noon, then trailed into camp. The boy asked me questions about Indians and cowboys and the long Texas trails. I like to talk to a person who is interested, so I told him a lot he never read in a dime novel. When we got to camp I cooked the big feed: spuds, fried onions, sourdough biscuit baked in a Dutch oven, fried ham, and beans. Charley was pretty empty. I always liked to see a hungry man eat, that is if I liked the man. After we had eaten we rolled brown paper cigarets and had a smoke. I told Charley old trail jokes, and wised him up a lot, for he wanted to be a cowboy. He said, "I asked Horace Brewster for a job on the round-up. He looked me over, and turned on his hoss and rode off. I think I didn't look good to Brewster."

Brewster was captain of the Judith Basin round-up. I said, "Brewster and I are friends."

"Maybe you could get me a job on the fall round-up."

I told him I'd do all I could. Maybe I could get him a job wrangling saddle hosses on day herd.

The round-up was soon to start, and the cowboys were congregating. Brewster wouldn't be back until just before time to send the men out. When he came I told him about young Russell.

"Tommy," he said, "do you think that boy is any good?"

"I think he might be all right for day-herding the round-up hosses."

"Where is he?"

I brought Charley to Brewster, where he was putting up a tent. Charley was timid, but he got the job.

"Forty a month, and chow," Brewster told him.

"What is chow?" Charley asked me when we got away.

"Grub."

He put his hand in his pants and pulled out a five dollar bill.

"What's that for?" I asked.

"Pay. For getting me my job."

"Put it back in your pocket. Pray for me when you do for yourself, and that will be all right," I told him.

"Now, Charley," I said, "I'll get a gunny sack, and we'll put your saddle in the sack. The boys will have a lot of fun with you if they see your pilgrim saddle. You can ride my extra saddle."

I remembered when I was a boy, 'way down on the Rio Grande.

"Where are you staying, Charley?"

"With an old trapper. Jake Hoover. I don't like it there. He's crabby."

"Got a bed roll?"

"I've got a bed, but no roll."

Then I did laugh.

Charley grinned and said, "This cowboy stuff is all new to me."

I told him a bed roll was three or four good blankets, and a tarp to roll them in. A tarp — tarpaulin — was a piece of canvas. He said he had two blankets and a quilt his mother had given him.

"Got any clothes besides those you've got on?"

"Yes, I've got extra pants and shirts, besides my Sunday clothes."

"Lord, Charley, we don't have Sundays out in the West, like they do in the States. Nobody wears fried shirts in the West, only gamblers and hoss thieves — and they aren't wanted around cow camps."

"I can throw my Sunday suit away," he said.

I was having fun with Charley.

"Tomorrow, Charley, you get your Calico hoss, and I will get White Bird and Bunky. You ride Bunky, and I'll ride my white hoss, and we'll take your pony along to pack your bed and war bag."

"What is a war bag?"

"A war bag is what you put your extra clothes in. You use it for a pillow."

Cowboys were trailing into camp, each on his own private hoss, with a pack hoss carrying his bed roll, and his war bag tied on top. Some of the men were old hard-riding cowboys. A lot of them were tenderfeet. It was the young pilgrims that did most of the talking. They were all strangers to Russell. He said nothing, but listened to what they had to say. They were telling each other what a time they'd been having since the spring round-up ended.

That evening the cook, Mike Ryan, was busy digging a hole where the camp fire had been. Charley asked me if he was digging a grave.

"No," I said, "he is going to cook whistle-berries in a Dutch oven, cover it with coals, put the hot earth back over it, and in the morning the whistle-berries will be ready for the boys' breakfast."

"Whistle-berries? What are they?" Charley asked.

"Beans," I said. This was an old joke we sprung on every pilgrim.

The next day Charley and I trailed eight miles up to Jake Hoover's shack. We were riding side by side, me talking all the time:

"You better steer clear of this Jakey Hoover," I said. "I think he's going to last quick on this range. Pass him up, Charley. If you want to be a cowboy, don't trail around with him." [2]

When we got to the shack Hoover was standing in the door. I knew him, and he half knew me. I told him I was going to make a cowboy out of Russell.

"You're too late. He's got a job on the round-up."

Hoover cussed Russell out: "You damn tenderfoot, don't you ever show up around my camp any more."

Charley said nothing.

Hoover got his rifle, and trailed off up the river.

Charley still said nothing, but went in and pulled his big trunk out of the shack, put the key in the lock, and opened the trunk up.

"Tommy, here is my wardrobe."

[2] Charles M. Russell visited Mr. Hoover from time to time, to the end of his life. Oscar O. Mueller, Lewiston, Mont., says: "The Hoover cabin is now in a dilapidated condition, and was rather a crude affair to begin with. The stone chimney and fireplace at one end have fallen down. Jake and Charley were not expert stone masons, as their work shows they did not break the joints properly. The windows of the original cabin were made by cutting out one log, leaving a slit, scraping the hair off a hide and thinning it until some degree of light could come through, and nailing it over the opening. Russell spent his first year or two up there with Hoover, hunting and fishing. He always enjoyed coming back for a visit, since he spent some of the most enjoyable years of his life with Hoover." —Ed.

I didn't know what a wardrobe was, and didn't want to know.

"Now you tell me, Tommy, what I want out of this trunk. The rest I will throw in the river."

He pulled out a big white nightshirt.

"Charley, if you put that nightshirt on in a cow camp the boys will think you are an evil spirit and put out your light."

Charley had everything in that trunk except money — fried shirts, paper collars, two straw hats, and two Panama suits.

"Go in the shack and get a gunny sack, Charley. I'll be picking out what you'll want on the round-up."

That trunkful of didoes didn't last, with me. I took what I thought he needed, then Charley and I closed the trunk and rolled it over the bank into the Judith River. He got his two blankets and quilt, I packed them on his hoss, put his war bag on top, put on a diamond hitch, and we hit the trail down stream.

Hoover had gone up the river, mad; but we were gone before he got back. I told Charley we would have to go to Utica, the stage station, to get a tarp for his bed. Utica was just building, that summer. Charley bought his tarp, fourteen-ounce duck, eight by sixteen. It cost the boy fourteen dollars.

"Well, Charley, you'll be right up on top as a cowboy after while," I said.

Russell was proud of his outfit, now that we were rid of the things he didn't need. He was the one who did the talking as we rode the three miles back to camp.

We got to the round-up camp just as the cook hit the dishpan for chow.

The next morning we rolled the cotton, moved camp for Arrow Creek, and got there just as the sun was going down. The round-up was to start there, with eighty-five riders. We could figure on ten hosses to each rider. This was a big outfit. There were eighty-six thousand head of longhorn cattle on the Judith range at this time, and the range was approximately ninety-five miles square.

Charley said, "Tommy, this round-up business is a continual round of pleasure. I've been to lots of shows, but this morning I saw a real show. Some of those cowboys can certainly ride the wild hosses."

"The real show hasn't started," I told him. "You haven't seen anything yet."

We camped at Arrow Creek four days, and branded several hundred calves. Charley liked to see the cowboys rope a calf by the hind legs and drag it to the branding fire. It was all new to him.

We were close to the stage road. The fourth day we were through with our work early, and were sitting around camp. Away down the stage road something was moving. We thought it was a Red River cart. When its driver came closer, he turned his hoss off the stage road and headed straight for our camp. Behind his bony old nag was a rattletrap one-hoss rig. The man who was herding this poor lame hoss was young but not handsome. His hair was almost pink. He had a big nose and a tenderfoot complexion. His hat was a stovepipe like the one Benjamin Franklin

wore, and he had on a long swallow-tail coat. His fried shirt had once been white, but he had come over a dusty trail. His paper collar had wilted.

He jumped down from his perch and struck the ground hard, shook himself, and proceeded to brush off dust with his paws. He looked mad and hungry.

He sat down on the grass without speaking, and opened a good-sized carpetbag, stood up, looked toward the sky, looked the savages all over, put out his tongue and licked the dust from his burned lips, and then said in plain English: "I'm a Minister of the Gospel."

There must have been something funny about the stars, for all the boys but me were looking up at the sky, laughing.

In the carpetbag were a lot of little blue books. The stranger began to deal them out, and didn't stop until every cowboy, cook, flunky, and hoss wrangler had one. He was so busy dealing out the books that he forgot all about his lame, tired hoss, but we boys didn't. Charley and I went out. I took the clothes off the hoss, and Charley took him to the hoss herd where he could eat and drink.

When Charley came back I said, "There's going to be a Wild West show in camp tonight."

"What'll it cost to see it?"

"Everything's going to be free."

I gave Charley the sign for him to keep mum.

On the front page of the preacher's little blue book was a brand that read:

HELP THE HEATHEN COWBOY
OF THE WEST

"Bowwow," barked the mad cowboys!

Just then Mike Ryan hit the old dishpan. That meant, "Come and get it." The young preacher asked me where he could make his toilet. I said, "You will have to go to the creek."

He looked different when he got back. All this time Charley Russell was not overlooking one thing. When he met a stranger he would not take his eyes from the stranger's face until he knew it by heart — unless the stranger looked at him and made him look away. Charley looked at anything that interested him as if he could never see it enough.

The preacher sat at the head of the table with the four big cattle kings of the outfit. They sat at one end of the long table, and at the other end nearest the stove the cook piled all the chow the boys could eat, and more. Each cowboy took a tin plate, knife, fork, spoon, and tin cup, and filled his plate with chow. The cook poured Java for each in his tin cup, and the cowboy went outside the tent, sat down cross-legged on the grass, and got busy. The cook tent was a big one. It would hold a lot of cowboys if they didn't mill around too much.

In the top of the tent, over the ridgepole, was a large square hole. After supper was over and the tent was full of cigaret smoke, I got Charley Russell back in a corner, brushed his Stetson to one side of his head

so I could get to his ear, and whispered to him that he was going to take part in the show.

"What'll I have to do, Tommy?"

"Watch the preacher, and see that he doesn't get my scalp."

"Okay. I'll be right there!"

The cook had a barrel to keep dishes in. I borrowed the barrel and put it under the hole in the tent. The preacher stepped up on it. He looked brave. The cowboys sat mum. A coyote made a sharp bark out on a hillside.

The young preacher stretched to his full height, pushed out his breast, and commenced. He told us about the Holy Range, and the Great Fatherly Captain Who Ruled All Ranges. When he ran out of wind he told us to sing a hymn.

I thought about the preacher not looking after his own lame hoss. I looked at the bunch and started "The Texas Ranger." All the boys joined in, and we finished with a real war whoop.

The preacher got off the barrel, drank a cup of Montana water, and stepped back up on his stand. He was on the war path. He looked wild, and made a big talk. We looked mournful.

"Please sing a Sunday School hymn, now," he said.

We started off with "The Cowboy's Lament," and finished up with another war whoop.

The preacher stayed on the barrel and looked ugly. He began to talk mean to us. We began to get mad, and I reached for my rawhide rope.

I was the lightest cowboy in the bunch. My friends

slipped outside with me and boosted me to the top of the tent so I could crawl to the hole in the center. The preacher heard nothing. He was popping off — first one hand striking out and then the other.

My loop dropped down under one arm and around his neck. Six of my friends were on the other end of my las' rope lying over the ridgepole. They pulled the preacher up off the barrel and let him down to the ground. They lifted him again, two or three times. He was talking all right, but not from the Bible.

We took the rawhide off him, and he put on his stovepipe hat and walked out of the tent. We watched him till he got to the stage road. He had his carpetbag in one hand, but he didn't wait to take the hoss he had ruined. He left that with us.

Charley Russell came to me before he bedded down that night: "I was beginning to feel sorry for that fellow. I thought you were planning to hang him."

I told him no, we had no notion of hanging him. We just wanted him to understand cowboys weren't heathens. So Charley said he guessed it was a good show.

Russell saw another show the next day. The morning after the preacher walked out on us we saw a cloud of dust about two miles down the stage road.

"That must be Indians on the war path," Charley said.

"It's hard telling," I answered. "Whatever it is, it's coming this way."

We were getting ready to move camp to the head of Arrow Creek. The boys had had their breakfast and

had saddled their hosses, and were standing around waiting for orders.

I rode over to Horace Brewster who was giving orders to the cook.

"How about that dust, Horace?"

He turned and looked, and saw the cloud coming closer.

"Into your saddles, boys," he called.

Prancing hosses craving action — men waiting orders — Russell and I side by side, our hosses' ears pricked toward the coming dust cloud!

As the billowing cloud came closer, the wind changed, and into sight jumped four wild hosses pulling the Fort Benton stagecoach with no driver on the box. We could see passengers with their heads out of the small windows, and hear them screaming.

"Rope them hosses!" Brewster's voice rang out.

"What'll I do, Tommy?" Charley asked.

"Sit tight, and watch the show!"

Six of us reached back with our spurs and caught our war hosses in the flanks. In less than ten minutes the Benton stagecoach came to a standstill, with a rawhide rope around each runaway hoss's neck.

Captain Brewster rode up, with the rest of the excited cowboys. Two pilgrims tumble out of the stagecoach and reach for the sky. Horace tells the crying pilgrims that we are honest cowboys, and that everything is all right. He asks them where the stage driver is, and why he got off the seat.

There were two Jew traveling men among the passengers. "Back a little piece," one of them answers,

"why, he got off the stage. My friend here, why, he throws out some paper, and the horses jump. That's all I know."

"Tuck, you and Frank Plunkett ride back and see if Billy Rowe is hurt," Brewster ordered.

Plunk and I rode back about two miles, and came to Billy sitting by the road on a bed roll. He told us he had wrapped the reins around the brake staff and got off the stage to pick up the bed roll, when one of the damn pilgrims threw out some paper and started the stampede.

Frank tied the bed roll behind his saddle, and Billy Rowe got up behind me. When we got back to the stage Billy said to the pilgrims: "You —— —— bastards, if you are going to ride with me keep your —— —— papers out of the road."

"I told you not to throw them papers out," the other pilgrim began; but Billy is still mad.

"Shut up and get in the stage," he said, "and get in right now, unless you want to walk."

He threw the silk into the leaders, and another cloud of dust went down the road.

3

Buckskin Shrinks

WE MOVED CAMP to the head of Arrow Creek. At the forks of the creek was a stage station called Geyser, owned by Pat O'Hara. Pat was straight from Ireland. He ran a few longhorns, but he made his easy money by selling whiskey to the cowboys. Freighters, trappers, and tenderfeet that traveled by stage always patronized Pat's rustic barroom.

He had the best of food at six bits a meal, and whiskey at two bits a shot. If a man got drunk and gave Pat a dollar to pay for a drink, he would put the dollar in the till and say, "I owe you six bits," and wink at the men who were sober. This was easy money.

Sometimes a pilgrim would stay over at the station a day or two. Pat had a great flow of English, and could spread the buffalo chips and lie without stuttering.

One Sunday afternoon, when we had got through rounding up and calf branding early, twelve of us trailed from camp to the stage station. Things had been too quiet for Pat, and he wanted action. A young

Englishman staying with him was looking for adventure, and wanted to see wild cowboys. Pat saw us coming, so he oiled the tenderfoot up. We cowboys rode up to the door branded SALOON, slid from the leather, hit the ground with spurs jingling, tied our hosses to the ground, and went inside.

The Englishman was at the door, looking at the savages through his eyeglass. The boys didn't stop. They were dry, spitting cotton. The boy with the eyeglass gave them all the glad-hand. Pat was wiping off the bar, getting ready for business. The dude's invitation is accepted, and the boys all take a drink. Bill Bullard, a big long-legged cowpoke, pats the man with the silver on the back. That makes the Englishman feel brave, and he tells the barkeeper to fill them up again.

We all take another drink, and hurrah for the Queen.

"Give the lads another drink," the tenderfoot says.

By this time the pilgrim is a hoss man, and steps outside to look the hosses over. Bill Bullard is trailing the dude, pulling his shooting iron as he goes. They are both walking crooked. A lone Indian buck is standing by the log shack. He can't move — too much firewater. Pat has got all his hides, and paid for them in whiskey. The Indian is paralyzed, but he is still standing up and his eyes are working.

The pilgrim is traveling slow. He sees a lot of saddle hosses. Bullard is making eyes at the boys, and walking tiptoe. His legs are shaky but his aim is still good.

He takes a crack at Johnny Bull's feet with his six-gun. That raised a dust. The pilgrim crowhops. Bill makes him dance the cancan while he shoots at his feet.

When Bill's gun belches fire, the Indian comes to life. He trails up the creek, moving easy. Pat grabs the Englishman and throws a jolt of whiskey into him, and then beds him down. He gives all the laughing cowboys a drink, and they get into the middle of their war hosses, give a big war whoop, get their spurs to working, and start for camp on a high lope.

Russell was sitting in the shade of his cow hoss on the side of a hill, taking it all in. His hoss herd was close by. He told me afterward that this was the first time he had ever seen a man dance to the music of a six-gun.

Young Russell was getting a cowboy tan on his face. He didn't talk much, but he saw everything that was going on.

We rounded up all the cattle and branded all the calves on Arrow Creek, then moved camp to Wolf Creek. When we got to Wolf Creek, Charley paid a half-breed three dollars for a pair of pants made of antelope hide. He put them on, one rainy morning. It rained all the forenoon, and the new fringed buckskin pants got soaking wet. Charley took on his noon meal, rolled a cigaret for a smoke, and got in the middle of his hoss to trail back to the hoss herd. The rain clouds were all gone when he got to the herd, and the sun came out hot.

I had to go to Stanford for the round-up mail, so I rode out to the herd to catch my private hoss. I could

come up to him anywhere. Charley was looking white in the face.

"What's the matter, Charley?"

"I'm bloating. My legs are swelling."

"No, Charley, your legs are all right. It's your antelope pants that are getting dry and shrinking."

I told him, "The buckskin wasn't smoke-tanned, and the pants are no good. That half-breed put something over on you."

Charley had thrown his old pants away, and he couldn't wear the buckskin because it was pinching his legs. I had to take a knife and operate on Charley's pants. I told him I'd bring him a pair from Stanford.

"Put on your slicker," I said as I rode away, "I won't be gone long."

When I stopped on my way back, Charley and I talked a long time. I asked him how he liked his job.

"Fine," he said. "I like to see the old bulls fight. When the boys trail in the different bunches to the round-up grounds, I can see the bulls on the range. They are always on the lead. When they come close to the grounds they begin to paw the dirt and make the dust fly. Pretty soon there are six or seven pairs of bulls fighting. I like that."

"Cow punching is a great life, Charley, if you don't wilt."

The days rolled by. The weather was beginning to grow chilly. Russell was always on the job. He saw everything.

One night I noticed the boys sat later than usual around the camp fire. I thought it looked as though

they were framing up a job on somebody. I didn't know who the victim was to be, but I thought it might be Kid Russell, as the cook had named Charley. The cowboys named the landmarks, and the camp cooks named the cowboys. Charley was the youngest cowboy in the outfit, not more than eighteen.

The next morning while we were riding circle together, Charley told me the boys were going to take him out snipe hunting that night.

I never did like to see the boys take a tenderfoot out sniping, for sometimes it turns out bad. I began to tell how once, when I was young and foolish, I trailed into a strange cow camp in Wyoming, and the boys took me out sniping one cold October night. My pal Charley was listening all the time.

"They took me in a boat four miles from camp, got me in water up to my belt line, gave me a sack, and told me to stand there and hold the sack open. They were to drive the snipes into the sack, and they told me if any of the snipes got past the sack to shoot them with my capable six-gun.

"Say, Charley, I camped in that lake till I damn near froze. Then I got wise and trailed to camp, high-heeled boots tripping and spurs dragging. They had taken my hoss. My pal was one of them. We had been bunking together, but no more after that!"

"What'll I do?" Charley asked.

"Those birds want you to go sniping, do they? Well, you go. Willingly. When they leave you alone holding the sack, they will make a big circle. You drop the sack

and beat it for camp. Get there before they do. Be there when they get there, and the joke is on them. See?"

Russell turned the trick.

There was many a joke played on the open range that has never been told.

4

The Cowboy Artist

THE ROUND-UP CLOSED late, that fall. We were all in camp on the Judith River at the Iowa Cattle Company's home ranch, after the round-up, and were paid off in gold and silver. Charley Russell drew one hundred and fifteen dollars, and felt good to have money he had earned himself.

Six of the boys got a winter job line riding, and I was one of the lucky ones. Cabins had been built for the line riders, and sheds for two hosses. These shacks were on the line of the cow range. There were five big cow ranches on the Judith, where the cattle kings hibernated. I told Charley he could ride the grub line that winter.

"How much does that job pay?" he asked.

I told him it gave him his chuck free, but he mustn't camp at one shack too long, until they got tired of him. My camp was on the Judith River close to the stage road.

Charley wanted to buy a saddle. Since I had to go to Fort Benton to buy winter grub, I told Charley to

come along. We would buy him a saddle at Sullivan's harness shop. Charley thought this would be great.

We trailed to Fort Benton early in October, with a Sibley tent and a small camp outfit. We made the ninety-four miles in four days.

As we rode side by side in the dusty stage road, I told Charley that I planned to make a hunt when I got back from Fort Benton. I could see Charley was crazy to go with me, but he wouldn't ask. Finally he asked, "Were you figuring on taking anybody with you?"

I said, "Yes." Nothing more.

"Who?"

"Well, I was thinking about a young boy with light hair and blue eyes and a pilgrim smile."

Charley looked around at me. He was sometimes bashful. "You mean me?"

When I laughed, he said, "I'll buy my share of the grub."

Charley was always free with his money. There was nothing small about him, ever.

"Jake with me," I said.

We got to Fort Benton and milled around a few days. Charley bought a new saddle, forty-five dollars; a new bridle, six dollars; and swapped his six-gun for a pair of buckskin pants that wouldn't shrink. We were about half organized, and I got into a poker game.

The game was made up this way: There was a poor widow woman with a roan saddle hoss she wanted to sell. The boys engineered a raffle to get one hundred dollars for the hoss. He was to be raffled by playing

poker for him at twenty-five dollars a corner. I bought twenty-five dollars worth of chips, and three other suckers bought twenty-five dollars worth apiece. We sat in, and played all night. I won the roan saddle hoss, and it cost me thirty dollars to get the three other fellows drunk so I could win him.

They told me old man Cabell, a French breed, had the hoss in his pasture; so I took the ferryboat across the Missouri and went over to Shonkin to get him. On my lonesome ride I talked to myself when I thought of my cheap saddle hoss. When I rode up to Cabell's shack the dogs raised the devil. The half-breed showed at the door mad, not seeing good, because the dogs had waked him too early.

I told him in English that I wanted Mrs. Flannigan's saddle hoss.

"Cayouse is die," he said. "He not do tataway befo'. Two mont', he lay down. You go up coulee, you find him."

I found him, all right. He was a good horse, but dead.

That cooked my eggs with the pasteboards. No more did I play cards.

When I got back to Fort Benton, the cowboys all made eyes at me, but I didn't get mad. Charley had been having a good time with the Piegan Indians while I had been gone. They were new to him. He had bought a buckskin shirt with lots of beads on it. He bought a drink when we got together, and I bought two more. We were brave, then, and I made a big talk to a Piegan buck, and made a good hoss trade. There

were two hundred Piegan bucks, squaws, and papooses in Benton. Charley looked them all over. Cowboys, bull whackers, mule skinners, Indians — all had come to Fort Benton for a rootin', tootin' time.

Bunches of cow ponies and Indian ponies milled around in the middle of the dusty street. A few soldiers from Fort Assiniboine were in Benton, but they didn't mix with the rest. The cowboys milled around in a class by themselves.

When it was entirely dark the big canvas dance hall was lit up. This stood at the upper end of the single street. When I thought it had had time to be running full blast, Charley and I trailed up toward it. I wanted young Russell to have a sight of wild life. We were almost to the hall when — Bang! Bang! — then more shots. The lights went out in the hall, and here came a bronc, bucking, kicking, snorting, and taking up the whole street. We could hardly distinguish him for dust, but as he sunfished by us we could see that he was dragging the leg of a piano with him. A crazy cowpoke had tied his bronc to the piano. To make sure of finding his hoss when he got through milling around with the painted cats inside the hall, he had slipped his rope in at the back door of the dance hall, and tied it to the piano leg.

The cowboys were smoking up the hall, and the drunken cowpoke's wild bronc bucked down the street swinging his piano-leg picket pin and stampeding all the hosses that were standing tied to the ground. There were bucking hosses everywhere, and their owners were whooping it up at the big tepee. It was

wild in Benton that night. Charley told me the next morning, "This butterfly life is great!" But for me, I don't care about mixing with wild cowboys when they are likkered up.

We put in three days here. The fourth day we bought our grub, packed our hosses, and got ready to hit the trail for winter quarters. The barn dog at the livery stable told us that a gambler at the dance hall got fresh the night before, and started to kill a cowboy; but the cowboy was too fast for him, and the gambler would gamble no more.

After the hosses were packed I checked off the grub to see if we had everything. We had overlooked nothing but pepper. I sent Russell in to John Green's store to get black pepper, and told him to get plenty. We always bought whole pepper and ground it in the coffee mill. Charley came out with a twenty-five pound sack. "That's too much," I said. I opened the sack and took out two pounds, and told Russell to take the sack back into the store and get a refund.

Fort Benton played at night, and bedded down in the daytime. There was nobody in sight, when we rode away in the morning, except two hungry squaws with their babies lashed to their backs. We gave them some silver, and rode away out of town.

On each side of the road going down to the ferryboat was willow brush. Charley was trailing behind the pack outfit, and I was leading the bell mare. As we got halfway to the river Charley called, "Tommy, there's a gang behind us coming like the devil."

I looked back. Down the road came a Chinaman as

fast as he could run, his queue sticking straight out. Behind, chasing him, were four hossmen, with Bill Cameron in the lead. Bill was sheriff of Meagher County. I turned White Bird around just as the Chinaman bowed his neck to jump into the willow brush. When White Bird felt my loop settle on the Chinaman's neck he braced his front feet and pointed his ears straight up. The runaway got to the end of the rawhide rope, and stopped. He was strong, but my hoss was stronger. Russell pulled his new six-gun. He thought maybe he'd have a chance to try it out.

"Don't shoot, Charley! Here come the Sheriff."

Russell didn't shoot, but he sat looking mean.

The Sheriff came up. He told me to lead the Chinaman to the river. A big cottonwood stood close to the bank, where river steamboats usually tied up. Bill threw the end of my rope over a limb of the tree, and that was the end of the Chinaman. He didn't kill any more pals with his meat cleaver.

Charley told me if my rope had broken he had been going to use his gun, anyway.

The Sheriff gave me a twenty dollar gold piece, and I split with Charley.

The ferry was owned by I. G. Baker and Company, and run by Mike Lynch. I gave Mike a drink. That made him good-natured, and we got a ride across the ferry free. When we rode off the boat on the south side of the Missouri, I gave Mike another drink, and took one myself. Charley looked dry, so I gave him one. We shook hands with Mike, and said good-by. The old bell mare and the four pack hosses hadn't

stopped when we did. They were trailing for the Judith Basin where the long grass grew.

We trailed along the dusty stage road, the old mare in the lead. Toward noon we saw the stage coming, with Billy Rowe driving. I knew he was dry, so I held him up with the big black whiskey bottle.

Billy put his foot on the brake staff, pulled in on his four-hoss reins, and the stage came to a standstill. The passengers didn't wait for orders, but came tumbling out; and when they hit the ground their hands went straight up. One female passenger was sweating tears.

I gave Billy Rowe a drink, and he handed me back the bottle. Billy looked wise. Russell looked dry. I gave Russell a drink. He looked brave. I wasn't dry but I took a drink anyway. White Bird worked his way among the passengers, and each one took a drink whether he wanted it or not. The white squaw took a nip, too. Billy Rowe said, "All aboard!" Half a mile up the road I could see the bell mare. She hadn't slowed up. I gave Billy one more drink, he shook hands with me, and we said farewell to the stage holdup and trailed on after our hosses.

Charley was saying nothing, but his mind was working. I knew he had wild dreams, but he kept them to himself. He saw every coyote, wolf, and antelope that stood on the high points watching us go by.

The boys were all in camp at the home ranch when we rode up. Soapy Smith sang out, "Tuck, did you bring that stuff what cures rattlesnake bites?"

The boys rolled out of the log shack. They looked dry. We all went to work packing in the groceries so we could turn the pack hosses loose. Then we sat

down on the ground. Soapy went into the shack and came out with a tin cup. I had four quarts of good old MacBriar whiskey in my lap. I was barkeep. We killed two quarts, then I called the boys to order. Young Russell could talk fast, now. He told the cowboys all about the stage holdup, and he could make a story real when he was telling it.

When Kid Russell got through telling his story, the boys made goo-goo eyes at me. That meant they were dry again; but I refused to give them anything more to drink until supper time. We all got up and milled around, and had chow ready in fifteen minutes: beans cooked in a bean hole in a Dutch oven, fried spuds, onions, sourdough biscuit, good old Java, and slow elk steak — that's longhorn steer.

I am still barkeep. I tell the boys to fill their tin cups full of coffee, and I'll put in the "cream." I use up all my likker making cafe royals.

We washed the dishes, and then filled the shack with cigaret smoke.

Bill Bullard was feeling good, and started to tell us his right name: "My name is Buckshot, better known as Whirlwind of the Plains. I've been hooked by buffalo bulls, bit by rattlesnakes, and scalped by Indians. This is my night to howl and I'm going to H O W L !" Some of the boys looked sleepy, but they all joined in the war whoop. Kid Russell was already bedded down, but the rest of us sat cross-legged and smoked, and told more lies than truth.

When the likker had worked down into our feet, we milled around a little and then bedded down.

The next morning we got up early. It was raining,

and the rain was mixed with snow. Oregon John made flapjacks, fried some rusty government bacon, and boiled the Java, while I decorated the table with tinware and put on the canned butter and black 'lasses. All the boys were dry, but they said the coffee hit the spot.

After breakfast Bill Bullard, Soapy Smith, Frank Plunkett — the Cowboy Prince, as the cook named him — and a cowpoke named Rusty all got into a poker game. They had beans for poker chips, one cent each. Their seats were four sawed-off logs. Bullard was short and fat, and had on a pair of patched pants held up with one home-made suspender. The gamblers kept their Stetsons on.

The shack had double bunks. Kid Russell was lying in one of the top bunks, his hat pulled well down over his blue eyes. I was braiding a rawhide quirt, but I could see Russell's eyes on the stud game, all the time.

The boys played about three hours. The Cowboy Prince had all the beans by that time, and cashed in six bits to the good. We ate our midday lunch, filled the shack with cigaret smoke again, and went out to put the leather on our hosses. Charley didn't go with us. He said he wanted to stay at camp and write a letter to his folks in St. Louis.

We rode out to the foothills to see that the cow ponies were on good grass and water. I was the first to trail back to camp. Charley had a good fire going in the fireplace. The table with its dirty canvas cover was pushed over against the single window. On it lay a bit

of cardboard with a picture drawn on it. I picked it up and took it to the door for a better light. There were the four poker-playing cowboys, with Bill Bullard looking just like himself, showing up the big square patch on the seat of his pants.

Kid Russell was standing with his back to the fireplace rolling a cigaret, with a tenderfoot grin on his face. I said, "Boy, you're the Cowboy Artist!"

When the boys got back to camp they lit two candles to inspect this perfect picture. It was drawn with a lead pencil, but it sure looked natural.

Charley Russell made a hit with the boys with that drawing. We got some water colors for him by sending to Fort Benton for them by Billy Cowles, one of the stage drivers. Russell painted the preacher hanging to the ridgepole of the tent; he painted the cowboys smoking up the English pilgrim; he painted the black bottle holdup by Tucker and Russell; and he painted the pony bucking the piano leg to pieces.

When I had a chance, I took Charley over to Antelope Creek to show him the battlefield where the Crows had cleaned up the Piegans. There was not a bone there. The Piegans had carried them all away. I told Charley the story of the battle, and he painted a picture of it as I described it, and gave it to me. It is lost, like most of his early paintings. He painted pictures and tacked them to the wall of whatever cabin he happened to be in. The nailholes are still in the walls, but the pictures are gone.

Russell was no broncho fighter; but when he saw a

would-be broncho buster that thought he could build a ride, Russell could paint him getting up from the ground with two handfuls of dirt.

He painted the Indian in action, his true features, his papoose, his squaw with her travois and ponies. He painted, as it was, a life that is now gone.

5

Duffield's Daily Dozen

RUSSELL TOOK A contract to paint a picture for John Duffield, a big hoss man who had a fine ranch at the mouth of Antelope Creek. Duffield wanted Charley to paint his new log house, barn, and all the hoss corrals. He was to pay Russell twenty dollars if the picture suited him.

Charley and I went over to Duffield's ranch. Mr. Duffield had had his hoss wrangler fill all the round corrals with hosses. The picture was to be twelve inches square. Mr. Duffield wanted it for his sister in Missouri.

Charley was always ready to kid the other fellow. He told me on the way over that when he had the picture painted, Duffield wouldn't take it.

It was bitter cold, with about two feet of snow on the ground. The wind hadn't started to blow, and the fence posts had a foot of snow on top of them. We got to the ranch all right, put our hosses in the big log barn, loosened their cinches so they could fill their paunches with hay, and went into the house.

Russell took a snug position by a window. He wanted to be where he could look at the barn and the hosses. He rolled one, but all the time he was looking out.

Mr. Duffield told me to come with him and see his Morgan hosses. We were out among the hosses for about two hours. The Chink cook came to the door and rang the big dinner bell.

"Well, Tuck," Mr. Duffield said, "let's go see what the Chink has for dinner."

When we went inside, Kid Russell was pushing smoke against the kitchen window pane, and the picture was finished. Mr. Duffield put on his glasses, picked up the picture, and looked at it a long time. At last he said, "Who is this fellow out behind the barn doing his daily dozen?"

"Why, that is Mr. Duffield," Russell answered.

"Now look here, Russell, do you think I would send a picture like that to my sister? I aimed for you to paint me on my Sunday hoss, out in front of the barn."

"Where I painted you was where I saw you. I can paint you on your war hoss, yet; out in front."

"What'll we do with that fellow behind the barn, there?"

"Oh, I'll bury him."

Russell winked at me, and in twenty minutes Duffield was on his Sunday hoss out in front, and the fellow behind the barn was covered up with Charley's paint brush.

Russell handed the picture to Mr. Duffield. He

looked it over a long time, once more, and said, "Charley, you are a mystery to me."

It had warmed up by the time Charley and I got back to our camp, and we decided to go hunting in the Belt Mountains. We packed our beds, grub, and a small Sibley tent on our two hosses, and headed for the tall timber. It drizzled rain all day. We made camp at the forks of the Judith River. The rain turned into snow, but when we rolled out from under the canvas the next morning the snow had stopped, the sky was clear, and the sun was showing on the high point of the far-off Highwood Mountains.

Our stuff had got damp, so we hung our clothes on the brush to dry. Charley had a black mackinaw coat. He hung it on a burnt stump, with the sleeves stretched over two branches that stood out on each side. When everything was attended to around camp we saddled our hosses and trailed up to the high country. Before we got to the top of the mountains we came to an open park on the side of the slope. Our hosses stopped, stiff-legged.

Charley whispered, "They smell something!"

The dead twigs beyond the timber crackled, and out jumped five blacktail bucks. Russell tumbled two, and I got one. We cleaned the three deer and hung them in a big fir tree. Under the tree Charley picked up a small piece of buckskin. We began to look around in the pine needles at the foot of the tree, and found more Indian stuff, an old comb, a piece of looking glass, and some beads.

Charley said, "I bet there is an old Injun taking a long sleep up in this tree!"

I climbed into the tree, and there, lashed hard and fast to the branches, was a dead Indian. He lay on a buffalo robe, wrapped in three or four buckskins. By his side was an old rifle with no lock. The skin was dried on his bones. I crawled down from the tree, and Russell crawled up.

Those old Indian graves always interested Russell. He stayed in the tree a long time. When he finally came down he had seen a lot of things that I had missed.

"That old Indian must have been a fighting devil," he said. "There are four scalps at his belt."

The Indian was buried close to the old travois trail that wound through a pass in the Belt Mountains. When I think of this body in the tree other things come to my memory.

We got into the saddle and trailed to the top of the Belt Mountains. There we split. I went down one ridge, and Russell down another. Both ridges would bring us to camp. I made camp first, and got the camp fire to going good. It was beginning to snow, and growing dark. I was in the tent whittling away at a candle to fit into the neck of a beer bottle so there would be light when Russell struck camp, when — Bang! Bang! — then some more bangs —

"Ho, Tuck! Why don't you come out?"

I knew all the time what Russell was shooting at. He was tearing holes in his black mackinaw that he had

laid over a stump to dry, that morning. To tell the truth, it did look like a bear, with its sleeves spread out over the branches that way.

We brought the mackinaw in to see how much of it was left.

Charley said, "I'm getting pretty empty."

"There's two of us. Put on some more wood, you bear killer! Can't you smell the Java cooking? The deer liver's coming up."

"I'll take my blacktail deer liver sunny side up," Russell said.

Spuds with onions, liver and bacon, sourdough flapjacks — take this kind of chow with likker from the old black coffeepot — take the big smoke and kill a few more bears around the camp fire — hear your hosses milling around in an open park, and know when they begin to snort that they surely do smell a bear; go out, and take two hours rounding them up and putting hobbles on them; back to camp, and bed down — you'll be so tired you go to sleep thinking of nothing.

Young boys had spooky dreams when they first came West. But young Russell would never tell me about his dreams or his future. He was always telling about what happened to him yesterday.

We got up early the next morning. After breakfast I got the hosses up and took the hobbles off them while Russell was washing the coffeepot, the two tin plates, and the two big tin cups. We made two trips into the mountains to bring out our game, and hung it up. We

filled up on bear steak, and after supper got so brave we killed more bears, deer, and bull elk than there were in the Belt Mountains.

More bear steaks the next morning, and then we rolled the cotton and hit the trail for winter quarters. We packed two hind quarters of our deer meat, and left the rest hanging in the fir trees. We had a friend, Dan Cochran, who had homesteaded on the Judith River. He owned a bull team, and we knew he would bring out the meat for us and take part of it for his pay. He had recently married, and would be glad of the meat.

He had only just married, but he had had to marry two instead of one. He had married a "Heart and Hand" woman from St. Louis. Dan was the highest bidder, and he got her. She wrote him that she was broke, and couldn't come unless he sent her one hundred eighty dollars for clothes, and a ticket. She was planning to come on the last steamboat that ever came up the Missouri River.

Dan couldn't read, so he took the letter to Charley Russell to find out what was in it. Charley told him his wife said she had no money.

"I'm not married to that gal, yet," Cochran said.

"Well, she lives in my home town," Russell said, "so she's honest and okay. You need a woman, and you better take her."

Dan weakened and sent the money.

Sally came to Fort Benton on the old Red Cloud steamboat. She had to come from Fort Benton to Utica by stage. All of us cowboys were milling around the

log post office that evening, waiting to see Dan's advertised gal. When the four-hoss stage rolled in, Billy Rowe stepped on the brake staff, and the hind wheels slid a little and then stopped. Sally was sitting on the front seat with Billy. Dan was standing on her side of the stage, close by it.

Billy looked the gang over and winked, and Sally looked down with a motherly eye and said, "Is that you, Dan?"

"Sure it's me," Dan said.

"Take the boy, Dan."

Dan reached up for the child, and Sally stepped down from the stage. Dan carried his new two-year-old maverick over to the wagon where he had his bull team handy, and Sally trailed behind.

The wagon had no box, just running gears. Dan settled Sally and the boy on the running gears, picked up his bull whip, and started his bull team for Johnny Ferguson's ranch. Mr. Ferguson was Justice of the Peace, and his ranch was a mile from Utica.

All the boys gave Dan the war whoop as he drove off, but he didn't look back.

The barkeeper said, "Mr. Cochran's credit is good at the bar," and we all stampeded to the bar and began to abuse Dan's credit. Russell held up his glass and said, "Lots of pretty girls in St. Louis, boys!"

We started home. As we were coming out of the jack pines into an open park, out jumped a blacktail deer, his tongue hanging out of the side of his mouth. Behind him was a big grey wolf. Charley and I wanted to see what would happen, so we got behind a clump

of jack pines to watch. The wolf got the deer to running in a circle. Then a second wolf came out of the jack pines, and the first wolf lay down to rest. The two wolves circled the poor deer three or four times; then one of them got close, made a leap, and caught the deer by the hind leg. He cut a hamstring, and the buck went down.

The wolves were empty, and they tore into the buck's entrails and began lopping them down.

There was a bounty of twenty-five dollars on grey wolves laid by the Judith Round-up Association, for wolves are bad on young calves. Russell and I slipped from the leather. Our guns belched smoke, and one wolf bedded down. The other stood his ground and snarled. Charley slipped a cartridge into the magazine of his gun, dropped to his knee, and when the smoke rolled away there lay two grey wolves. We skinned them out, and were fifty dollars to the good. We tied the wolf pelts to our pack hosses, and rode on.

We were out of the foothills, following the wood road and coming right along, when Charley said, "Tuck, there's somebody down on the creek flagging us in."

I looked down on Antelope Creek. A newly built log shack stood there, and in one of its windows was a white rag waving back and forth.

"There's something wrong down there, Charley."

"Let's ride down."

We headed our hosses for the shack. At the cabin door lay Jack Coburn, dead, shot through the heart with a forty-five ninety. Jack was a tinhorn gambler.

He used to lie around Utica, and when the cowboys, trappers, prospectors, and freighters were drunk and looking for a stud game, Jack was always open for business. He was a crook.

The people who lived at the cabin were a young couple from Virginia. They had taken up a homestead on Antelope Creek. I had seen them in Utica at the dances. She had black hair and snappy eyes, and was a fine dancer, and Jack went crazy over her.

The night before, when Jack knew her husband was up in the timber getting out fence posts, Jack got brave and rode out to the homestead. He knew she would be alone, and thought he'd have a chance to make love to her. He found the door locked. Jack asked to come in. She refused him, and he begged. He told her he had more money than some folks had hay and straw. But money didn't slip the bolt on the door for Jack, and after while he got mad. He got mad and strong, and gave the door a kick. He cracked one of the rough boards, but the next crack that came drove a chunk of lead through Jack's heart.

We pulled the dead gambler away from the door, and the woman got up enough courage to lift the bolt and come out. She told us what had happened, while tears ran down her cheeks. Right there Charley and I took a solemn vow never to kick in a door when the lady of the house was alone.

She wanted to go where her real sweetheart was at once, but we knew she was hungry, and begged her to eat some of our fresh deer meat and drink a cup of hot coffee. She tried to, and ate a little bread and

fresh meat, and drank the warm Java we fixed for her. I told her she could have my saddle hoss, and Russell would go with her to find her husband and bring him home. I promised to close herd the cabin and keep the coyotes from Jack.

Charley and the young woman went off on a high lope. I took the packs from the pack hosses, and turned them loose to feed. When the sun was beginning to make red shades on the scattering clouds, Charley trailed back to the homestead leading my hoss. The young couple were coming behind him, sitting side by side on a load of fence posts.

The husband thought it would go hard with his wife, but we told him it was plain she shot in self-defense, for the gambler had a six-gun on him. I always carried rattlesnake medicine, so we each took a drink. I fried bear steaks. If you take a shot of good likker and then fill up on bear meat you'll never plead guilty to anything. We four were good friends by this time. At dark Russell and I put a loop on Jack Coburn's feet and snaked him to the hoss shed. Then we had a smoke, and bedded down for the night.

We had a real breakfast the next morning. Leave it to a female to put flavor in your grub. This was the first meal cooked by a woman that I had eaten in eleven years. There was no buffalo chip dust mixed with this food, and it was dished out on clean white plates. I think the cups and saucers were made in China. Lottie — that was the only name I knew her by — told us these dishes were a wedding present to her down in Virginia, when she married Bob.

We cheered her up about shooting Jack, and told her she ought to have a bounty for bedding him down. After breakfast we rounded up our hosses, but Russell said we had to do something with the dead gambler.

"Leave him in the shed," I said.

"Better take his stuff. He's got a big diamond ring — maybe money. We'll take his stuff and leave it at Johnny Ferguson's."

Jack's finger was swollen, but I got the ring off. I took his watch. He had a thick pocketbook, but we didn't look in it. After we had stowed these away, we wired the door shut, and left Jack safe.

We started for Utica, the young people riding the wagon, and Russell and I trailing behind. When we reached Utica, Charley and I gave in the evidence and the Virginia bride came clear. The Justice of the Peace, Ferguson, sent some boys out with a buckboard to bring in the body. Old Dud Rickard made a coffin out of boards, and drew ten dollars for putting Jack six feet under the bunch grass.

The young people went back to their homestead, but they didn't stay long after that. They went farther west to new range. Jack Waite paid them for the improvements on their land, so they had plenty of money to go on. They were good people, and had good friends. No one wanted to see them leave.

Charley and I milled around Utica a few days after this affair, and then went to the home ranch and washed our clothes. We took a bath in a tub made out of a whiskey barrel. The snow was deep again, and it

was freezing cold. We lay around the ranch a few days, but we craved action, so we went trapping wolves. But something happened, and we didn't last long.

6

A Slick-Ear

THE BRAKES OF the Missouri were alive with grey wolves that were cleaning up on the young calves. We got grub together, and a supply of No. 4 traps. I took my tepee, and plenty of blankets and buffalo robes. There were two good saddle hosses and four pack hosses in our outfit.

We trailed sixty-five miles to the mouth of Arrow Creek. There was a real mountain blizzard raging, and it was cold; but we got to the Missouri River, where Arrow Creek empties into it, and camped at the mouth of the creek. There was a foot of snow on the ground, but we cleared a spot under some cotton-wood trees and put up the tepee. We banked snow around it, and stowed away our grub and five hundred rounds of ammunition.

The tepee had a hole in the top, all the same as an Indian tent. We built a fire in the center of the tent and cooked a big meal. Then we smoked, and bedded down for the night.

A quarter of a mile down the river, in cottonwood timber, some old Piegan bucks and squaws were camped, trapping for beaver. We had seen their camp, and had talked of going down to see them. The wolves ran in packs in early days, and the wolves and coyotes made plenty of noise that night. I didn't sleep good unless wolves and coyotes made music for me.

About midnight my feet felt hot, and the tepee was full of smoke. We grabbed our Stetsons and jumped out in the snow, and by the time we got outside the tepee was ablaze. Then the ammunition began to pop. Talk about a stampede in a fog! Charley Russell and I fogged it to the Piegan camp in our bare feet.

The old Piegan bucks had wakened when they heard the shooting, and were standing in front of their tepees with guns loaded for action. Charley and I didn't stop — it was too cold. We had no guns, but we ran right into the Piegan camp and begged for our lives. The old bucks didn't have war paint on, so they let us into their tepees. They had been camped there for some time. Their tents were nice and warm, but they certainly did smell strong.

The bucks made fun of the barefoot cowboys. We had nothing on but our shirts, pants, and Stetsons. We played Injun for a few days, and got the squaws to make us shoes out of pieces of old blanket. The third day we took the trail back. We had no war paint, but we had Injun blankets wrapped around us, and we smelled like brave squaw men.

Everything we had went up in smoke at the mouth

of Arrow Creek, except our saddles and a little silver in our pockets.

We paid the Indians for the blankets, and when we got back on the Judith Charley got the blues and drew a picture of himself. He drew himself running through deep snow, bare naked, with Indians and wolves chasing him. He sent this picture to his folks in St. Louis, and they sent him a Christmas present of two hundred dollars. Then all the cowboys had money and whiskey for Christmas.

Our Christmas lasted six days, and we had a rollicking time. We had whiskey in our coffee, whiskey in our mince pies, hot whiskey, cold whiskey, and none of us were feeling bad. We were feeling good. Calico in the kitchen there was none, nor any crabby landlady to spoil our fun. It was cold enough outside to freeze one's hide, and the Cowboy Prince told so many lies he got tongue-tied. The days grew colder, and the snow deeper. Christmas was gone, but we sang our old song, "The Girl Buckaroo."

One bitter day in February, when the snow was drifting around our shack, Charley Russell came in and said the Indians were coming. He said it without a smile, but the cowboys had been scalping Indians around the fireplace all winter, so Charley's story didn't get them excited. We all went out to look, and surely enough we could see Indians on the other side of the Judith River. There were two, a buck and a squaw, riding ponies. The squaw was leading a pony that dragged a heavy travois. The old pony, with a

little colt at her side, was earning her bunch grass pulling those two long, loaded poles. All manner of Indian junk was lashed on to them.

We watched for other Indians, but these two were alone. We saw them pull into the willow brush and put up their tepee. The buck was an old medicine man mooching around the country.

When they had their camp in shape they came over to our shack. The buck was heap hungry. We let them in. They were old, dried-up Piegans, but we filled them so full they couldn't grunt. Every two or three days they would come back to our camp. The old fellow would say, "Heap!" and rub his belly. That was his way of saying more grub. One day the rest of the boys had gone to make a circle, and Russell and I were alone in the shack. In came our neighbors, the old buck and squaw. We filled them up on sourdough and elk steak. I had two pieces of pie in the grub box, so I gave one to the buck and one to the squaw. The damned old buck ate both pieces, and that made me mad. I had a lot of sour beans in the Dutch oven. I filled the old buck's tin plate with these, poured black 'lasses over them, and let him go to it. He licked them clean, and got a belly-ache. They beat it for home. We lost our neighbors, for they never did come back.

The days grew long, and the sun got warm. The wild geese were beginning to honk as they flew overhead to the north country. Snowbanks were melting fast, bunch grass was showing green, and on the side-hills were thousands of cattle feeding. It was spring.

The ice in the river was gone, and on May fifteenth the big round-up was to start. Eighty-five thousand head of longhorns were to be rounded up, and their calves roped and branded. The cowboys were beginning to congregate.

On May twelfth, Charley Russell, Jim Spurgeon, and I were sent down on the Judith River to round up saddle hosses. It was a warm day. We trailed to the mouth of Wolf Creek. We had grub in our saddle bags, so we got down off the leather and let our hosses fill up on the young, tender grass. After we had cleaned up our lunches and had had a smoke, we tightened the cinches on our saddles, and split up. Charley went up Wolf Creek, Spurgeon rode the high country, and I trailed up the Judith, for in midday the hosses would be on water — this is always the case in hot weather.

There I was, riding along on my old Texas cow hoss, White Bird. The sun was coming straight down. You may know it is hot when a cowboy sweats in the saddle. I knew I was dirty, because I smelled dirty. A cowboy took a bath once a year if he needed it — if he didn't he wouldn't. God Almighty provided him with shower baths, but didn't arrange for him to take his clothes off when they came along. When God got through making it rain, all the cowboy had to do was take off his boots, turn them upside down, and let the water and hailstones run out.

Riding along the river bank I came to an old beaver dam. The water looked good, and was deep enough to swim in. I slipped from the leather, turned White

Bird loose to fill up on bunch grass, and started to undress. But the ground was alive with piss ants, and I didn't want them on my clothes because they bite like the devil. I took off my clothes and boots and tied them to my saddle. Then I made the high dive.

The water was just right. I stayed in a long time, until I began to feel weak. I crawled up on the bank, and started for my good old cow hoss. When I was almost close enough to reach him, he threw up his head, pointed his ears to the sky, and gave a snort. I didn't smell right to him. He circled me three or four times, then threw up his tail and galloped for the bench land.

No hoss, no clothes, one hundred in the shade, and no shade! I remembered that if I died I would go straight to heaven, for I was one clean cowboy.

I bowed my neck and took a squaw trot to the top of the bench, and there was my white hoss standing broadside, making eyes at his old friend. When I got close to him again, and was about to pick up the hackamore rope, he gave another snort and that was the last. He lit out on a gallop.

Fourteen miles to camp, bare feet, prickly pears, and no insurance! I was as bare as the day I was hatched, but I was running all the time. The last I saw of my hoss he was making a bee line for camp, running in a mirage, floating along like a bird with my stirrups sticking straight out.

I made a bloody trail. The prickly pears were as thick as hairs on a coyote's back, and the sun was taking the tallow out of my backbone. According to

the Good Book, God is everywhere, but He wasn't there that day. I have been chased by Indians, and scared by rattlesnakes, but I had never known anything like this. I remembered the prayers my old gray-haired mammy taught me to say, and I prayed and ran. I had to travel fast to kill the pain. I got to a high ridge, and was just beginning to spit cotton when I saw the cowboys coming my way. I didn't stop. I kept moving. I saw it was Charley Russell leading my white hoss, and the Cowboy Prince coming on a high lope.

When they came up to me I faded like a wild rose. I didn't wake up for two days, and when I came to I was lying on a canvas, with flour under me and flour over me. The boys were still pulling stickers out of my feet.

Mike Ryan, the round-up cook, was the camp doctor. I was pretty weak and empty, but my heart was still pounding strong.

Charley Russell painted my picture. He didn't put any clothes on me, and I looked like a slick-ear. I didn't ride any hosses for three months. I traveled in the bed wagon, and kept tally on the branded calves. Then, one day, I shed my skin like a rattlesnake, and was as good as new.

7

Rattlesnake Country

CHARLEY RUSSELL WANTED to see the battle ground where General Miles made good Indians out of the Nez Perces. That was where Chief Joseph held up his left hand — his empty rifle in his right — while one of his subchiefs at his side held up the flag of truce: "From where the sun now stands I fight no more against the white man." We had two weeks' lay-off between round-ups, so Russell and I packed our hosses and trailed over to the Bearpaw Mountains.

We crossed the Missouri River at the mouth of the Judith. T. C. Powers had a trading post there named Clagett, run by Bill Norris. Russell and I camped with old Bill for a few days. We didn't get drunk, but just took on a few drinks every day. Charley would buy one, then I, and then Bill would say, "Take one on me." When old Bill had had three or four drinks he always got brave and began killing Indians. He buried them in the Missouri. He knew Indians, and Russell wanted to hear him pop off, so Charley bought him a few drinks to get him started whenever he crossed the

Missouri, and always painted a picture from his stories to give old Norris.

We camped at Clagett four days, and our hosses bailed a lot of bunch grass. A cow hoss is like a cowboy, he likes high country in hot weather. It gets so hot along the old Missouri in summer time that it would slip hair on a bear.

The morning of the fifth day a band of Piegans camped across the river. They pulled in sometime during the night. There were twenty tepees.

"Let's go over to the Indian camp," Russell said.

"All right, Charley."

We rolled our beds, packed our hosses, threw the diamond hitch and tightened it up, and got into the middle of our cow ponies. The bell on the lead mare began to jingle, and the cow hosses and our pack hosses began to switch their tails. We hesitated a few minutes in front of Bill Norris's store. Bill was standing in the doorway.

"Get off, boys, and we'll have a friendly drink."

We took a drink on Bill, then Charley bought one, and Bill told a short story. I bought one, and Russell bought a bottle. I begin telling Russell that rattlesnakes are bad in the Bearpaw Mountains. The bottle is still on the bar. Bill gives it a couple of shakes: "One more drink won't hurt you any, boys!" Then we shake hands with old Bill, the Indian trader. I go outside and fix a loop on the bell-mare, and we trail to the ferryboat. Russell trails behind. The old cow hosses move when the bell-mare shakes the bell.

I. G. Baker owned the ferryboat at the mouth of the

Judith River, a half-mile up the Missouri. The ferry was run by Jack Dole. He had a blind tiger in the brush a little way from his shack. Jack told me there were a lot of rattlers on the trail we would take over the Bearpaw Mountains, and that meant more likker. I bought a gallon, and Jack threw in two drinks. He untied the old ferryboat, and we started across the river. The Piegans were just beginning to stir around.

They came to the river to trade. They were from the north country, and had quite a lot of beaver skins that they had packed in with their beds and grub on travois. We camped with the Indians until after dinner, and bought some buckskin and dried meat. After we had smoked, we hit the trail for the head of Plum Creek.

We were moving along, slow and easy, when the old bell-mare stopped short, stepped off the trail, snorted, turned her head, and put her ears straight up. A big rattlesnake lay coiled in the middle of the trail. Russell pulled his bottle, and we each took a drink. Russell got down from the leather, took aim with his six-gun, and hit the rattler between the horns. He cut the rattles off and put them on his hat. Sixteen rattles! He was a big snake. We took a drink out of my jug.

"Do you want the cantle of your saddle decorated?" I asked Russell.

"Sure," he said.

I skinned the snake and stretched the skin on the cantle of Charley's saddle. A snake skin has lots of glue in it, and if you stretch it on the cantle of a saddle

while it is still warm, it will stick until the saddle goes. We took another drink, and got in the leather.

"Tuck," Russell said, "we better kill all the rattlesnakes we see, because somebody might come trailing along here that didn't have any likker." We were in rattlesnake country, and we wanted to keep soaked with likker, so if we got bit we wouldn't die.

We trailed along till we came to Hoss Thief Davis's ranch. This old hoss fighter had two names. He was a gun man, but Russell and I had been killing rattlesnakes and drinking likker all the afternoon, so we were brave cowboys. We trail right up to the shack door. The old hoss fighter comes out, both hands on his hips. His gats were stuck down in his buckskin pants. He smelled whiskey, and invited us in for the night. There was nothing Charley liked better than to have these old Indian fighters tell about their escapes.

Stud Hoss Davis's folks were Mormons. He was woman shy, so he quit the Mormon range and came to Montana. When he was a boy he did most of his traveling with the Indians. He had a small band of ponies that he ranged up a blind canyon. His shack was built at the mouth of this canyon against a rock wall, with portholes in the logs. Nobody could come at him from behind, they had to come to the front. This old boy had been a hoss man all his life.

We took the packs off our ponies, and then all had a drink. It took three or four drinks before Davis began to loosen up.

"Say, fellows," he asked us, "do you like beans that is cooked in a bean hole?"

I said, "Show beans."

He took an old shovel, went out behind the shack, and dug in the ground sixteen inches. He used a wagon rod with a crook at the end to lift the Dutch oven out of the bean hole. He filled the hole, packed the oven into the shack on the iron hook, and set the baked beans on the dirt floor. Then he took off the lid. Say — if you want real baked beans!

While the beans were cooling we took a drink. We mixed our groceries with the Stud Hoss man's spuds and sourdough bread, and when the chow was ready we took one more. Davis was talking all the time. Charley kept pushing me with his knee. Everything was working just as we had framed it. After we had eaten, and washed our tinware, and were taking the big smoke, Hoss Thief Davis began to tell his personal recollections.

"I had a hoss," he said, "that I thought was the best hoss in the north country, but the Blackfeet had a hoss that fleeced me out of nine good hosses that I bet against him."

"What was the distance?" I asked.

"A quarter-mile. And I tell you, cowboy, this hoss of theirs is a cyclone."

"I've got a hoss named Bunky that has beaten every hoss between the Rio Grande and Montana."

When I said that, Davis went straight up and began to talk fast. He told us that the Blackfeet who owned

this fast hoss were camped in the foothills of the Little Rockies, and that he would go over there with us.

"Tuck," he kept saying, "if your hoss is as good as you say he is, we can clean that Injun camp. They've got beaver skins, and they'll bet their last pony and blanket on that hoss of theirs."

Charley Russell would never gamble, but he enjoyed sport. We spent two days with that old Mormon. The third day we rolled the cotton and trailed to the Little Rockies. At noon we camped in the pass between the Little Rockies and the Bearpaw Mountains, on the Fort Benton road.

I always packed my bed on my Bunky hoss. He was a dark buckskin, with a black streak along his back and dark rings around his legs. He was hatched out down on the Rio Grande, and his mammy was a Spanish mustang. He had wide, flat hoofs, and could swim like a duck. I liked a standing start in a race, because Bunky was wise to the game. His first jump was in front of the other hoss. That always gave him the lead. A quarter-mile was his distance. I was a light rider, one hundred and thirty pounds. In a race I stripped my clothes and boots, and rode Bunky bareback.

As we came up, we could see the Blackfeet tepees in the jack pines. Their ponies were feeding on the bunch grass while we were cooking chow. As we were eating, Sam Pipen and his boy, Lew, drove up in a buckboard. Charley and I knew old Sam Pipen. He had been wagon boss for the I. G. Baker freight outfit.

He and his boy were trailing for Fort Belknap. We shook hands with them, and Sam got out some rattle-snake medicine and we all took a drink. Sam had fresh antelope meat with him, so we mixed his meat with our groceries, and all had a big feed. We lighted up and smoked. Sam had sporting blood in his veins. He knew my Bunky hoss, and he knew the Indian hoss, Black Feather; and he wanted to get action on his money. He and Stud Hoss Davis trailed up to the Indian camp, Sam riding my hoss, White Bird.

They were gone three hours, and framed a race to take place at the Blackfeet camp, next day.

We were taking on chow just as the clouds were turning purple-red and the hot July sun had said good-by, when here toward our camp came six Black-feet Indians all dolled up in war bonnets, but with no war paint on. We filled them up on white man's grub. They wanted to see the race hoss, so I took a lump of brown sugar and went to the sidehill where the hosses were feeding on bunch grass. Bunky saw me. His ears went up. He made a noise like a colt, and came straight to me. White Bird came too.

The old Indian chiefs walked all around my race hoss, and made talk with their hands. Charley Russell was young, but he savvied Indian signs. Bunky was a sleepy-looking hoss, but when he stood with his front feet on a las' rope ready for the big jump, he would wake up — and his ears would be working all the time.

I didn't let Bunky have much bunch grass that night. In the morning he was hungry and mad. We trailed up to the Indian camp, and by the time we got

there he was hungrier and damned mad, and I couldn't keep his face out of the bunch grass. While I was holding him to keep him from eating, Russell and Pipen and Stud Hoss Davis were counting out beaver skins. The old Blackfoot chief led out Black Feather. He was a long, rangy, smoky-blue pony. Walking by the chief's side was a bow-legged Indian boy. He was a light-limbed lad, but he was a peacock when the old chief put him in the middle of Black Feather.

I had eighty dollars up against forty beaver skins. Hoss Thief Davis had ten hosses up, hoss for hoss. Old Sam Pipen had two hundred and fifty dollars against buffalo robes, beaver skins, and such Indian trinkets as beaded shirts and moccasins.

I was on my hoss, the Indian boy on his, and both of us ready to go. The hosses were ready, front feet on the las' rope. An old Indian held a blanket in the air. Bunky was standing sideways. The blanket dropped— Bunky turned and made one spring and cut the Indian pony out. And he kept out. But the Indian hoss was so good that if we had had to run a hundred yards farther we would have lost the race.

One thing I can say for a true Indian: when he is beaten he doesn't squeal. I won the forty beaver skins, Mr. Davis won all his hosses back, and Sam Pipen was a big winner. He gave me one hundred dollars for my beaver skins, and I cut it with Russell. The Indians didn't get mad, and neither did we.

This race was run on the old Nez Perce battle ground.

We trailed back to camp. Sam Pipen cut his likker in

two, and we all had a drink. Russell painted a picture of this hoss race, and Pipen slipped him ten dollars for it. Russell cut it five with Hoss Thief. Davis tied a gunny sack around his belly and cooked chow. While we were cleaning up the chow, a band of antelope came around the point. Russell slipped out and plugged a big buck with his six-gun. Lew Pipen helped Russell skin it out and bring the fresh meat to camp. We had liver and bacon for supper.

While we were smoking after supper, Sam Pipen told us he had never gone to school, but he intended to give his boy a good schooling. Charley told Pipen that he had been born in St. Louis. "There were lots of schools there," Charley said, "but I was so busy I never had time to go to school. Yes, I believe I did go one day—my brother got sick, and I went in his place!"

It was my turn to tell one:

"Down in Texas we go to school on hossback. I went to school three months. We had a rodeo one day at noon. I got on an old brindle milk cow. She bowed her head, and bawled and bucked and sunfished. The hayseed who paid taxes on her lived three hundred yards from the log schoolhouse. When the cow got to the home shed, she swapped ends, and I got up with two handfuls of something I didn't want. I went to the creek to wash, but the man who owned the cow was on his way to the schoolhouse. The schoolma'am met me at the door with my slate and primer and a piece of paper. She told me to give the paper to my daddy.

"I got on my roan hoss and trailed home, four miles. My dad was sitting on the porch. I rode up, slipped down from the leather, and he saw the slate and primer in my hands.

" 'What's the matter? Are you through school?'

" 'Yes. I rode a cow through.'

"I gave him my diploma. He read it, and leaned over to knock the ashes out of his corncob pipe. Then he laughed.

"The next morning I commenced to ride again, and I've been riding ever since."

8

Three Kinds of Cowboys

WHILE WE WERE telling stories, Lew Pipen was barkeeper. He got so busy listening to his father tell how he once stripped himself naked when he was a boy, to make the Indians who were after him think he was an evil spirit, that he put too much brown sugar in the cafe royals, and made us sick.

Russell didn't mix his drinks. What he took, he took straight. He said, "I don't want you boys to die. I'll mix one." Instead of sugar he put lots of H H H liniment into the next one. Then he gave us a shot of pure likker, and bedded us down. We slept fine.

The next morning the camp was surrounded by Indians. They had no war paint on. They were the Blackfeet, who had come from their camp to eat breakfast, shake hands, and say good-by. We had plenty of grub, so we filled them up. After the big smoke I went out and wrangled the hosses. Russell, Hoss Thief Davis, and I shook hands with the Blackfeet, said good-by to Pipen and his boy, and hit the

trail for Mr. Davis's shack. We didn't see any rattle-snakes, but we were in rattlesnake country so we pre-pared for them. We got to Davis's shack early in the evening. While he started the beans to cooking in the Dutch oven, I fried antelope steaks and Russell cooked the spuds and onions. Old Davis threw the tin plates and three cups around, and we three sat on the grass, cross-legged, and tore into the chow.

We bedded down early in Davis's log shack, and got up early. Davis got out his wagon rod with the hook on one end, and hooked out the Dutch oven. We filled up on antelope steak and beans.

Russell and I had a little likker left, and Russell said we must split with Davis. Hoss Thief liked us, then.

"You cowboys have been good to me," he said, "and I'm going to give you the pick of my little hoss band."

Charley filled up three cups of old MacBriar when Hoss Thief said this, and we drank it down. Then Davis wrangled his ponies into his round hoss corral. I put a loop on a jet black gelding, and took a turn around a post. The black hoss made a run, and when he came to the end of the las' rope he went straight into the air, fell, and broke his neck.

I looked at Charley and Charley looked at me.

"Take off your rope, Tuck, and grab another hoss!" Davis called.

A blue roan was standing making eyes at me when I got my rope ready. He was a broke hoss, and when he felt my rope settle he walked right up to me. Now Russell's rope went up in the air, and dropped on a

buckskin. He was a broke hoss, too. We got our ponies out of the corral, necked them to our pack hosses, rolled our beds, packed our hosses, took a drink and shook hands with Hoss Thief, and hit the trail. Davis said, "Good-by, and here's hopin' your Bunky hoss will win us another bunch of hosses, sometime."

We trailed out of the high country and headed due south for the Missouri River, making a dry camp in a bunch of jack pines on a high ridge. While we were eating, the hosses pricked up their ears, and we came to our feet in a hurry with our mouths full of Stud Hoss Davis's baked beans. We saw smoke from a steamboat away to the east. We sat down and went on eating. The hosses' ears went up a second time. We looked across the canyon, and there on a high ridge was a bunch of ponies.

Russell said, "Tuck, I bet that bunch of ponies are some that belonged to the Nez Perces."

When General Miles cleaned up the Nez Perces, he took them off the range for good. So I told Russell we would grab this bunch of ownerless ponies, and trade them for some silver. We weren't stealing any hosses, we were just beating the other fellow to it.

I threw the leather on my race hoss, Bunky, and Russell put his hull on the buckskin that Davis had given him. We got into the middle of our hosses and hit the breeze. Our other hosses were camp broke, and would stay right where we left them. We crossed the canyon and popped up in sight of the Indian ponies. They started to mill around, and we got close

to them. They were milling around a little baby hoss about three days old. They didn't want to run away and leave him. I threw a rope on him. He bowed his neck and made a buck or two, and his mammy ran up to him. She wanted her baby. She came close, and Russell got a loop on her. When the lasso settled on her neck she went up to Russell.

There were nine head of these ponies, all trail broke, so they were easy to get to our camp.

We rounded up our little bunch of hosses, put the packs on the pack hosses, and took the high country for the Missouri River. We hit the river three miles below the mouth of the Judith, and trailed up the river to the ferryboat. The Piegans had pulled camp and gone north, and the Silver City steamboat was tied to a big cottonwood tree. They were taking on cordwood, and I noticed their captain was old Bill Massey. I didn't like him. I remembered him for a bad actor and a dirty crook. Once, at Cow Island, I had seen Billy Mitchell's four men load cordwood for Massey. I was sitting on my hoss watching them. When the wood was loaded, Mitchell sent one of his men aboard to collect the money for it, and Massey didn't want to pay what he had agreed to.

Mitchell's man came ashore and told his boss that Massey wanted to cheat him. That made Mitchell mad, but he didn't say anything. Massey sent a deck hand ashore to untie the boat rope from the old cottonwood tree, and Mitchell pulled down on him with a gun. The boat hand jumped for the gangplank

and ran aboard. Massey came out with an axe, but when he lifted it to cut the hawser Mitchell called, "Massey, you drop that axe and I'll drop you!"

The old steamboat crook said, "Come aboard, and I'll settle with you."

Mitchell said, "You come ashore, or I'll fill you with lead."

Did he come! I'll say he did. He paid Billy Mitchell eight dollars a cord for twenty-five cords of wood.

We started to take the packs off our hosses, but before we could get them off old Injun Dick came out of Bill Norris's store, looking mad.

"Where did you cowboys get them ponies?" he asked. "I been close herdin' them ponies all winter."

Injun Dick was a half-breed Chippewa, and a gun man. He made his living trapping, stealing, and hiding from the law.

Russell said, "What you going to do about these ponies? If you want to start something, go to it."

Injun Dick had just enough of Norris's likker in him to make him brave. He reached for his gun, but he was too slow. I had him covered. I told him to reach for the sky, and Charley took a gun and a big knife off him. Then Charley said, "Come on in and have a drink."

Dick hesitated, but he trailed Charley in and I trailed Dick. Some old Sourdoughs were sitting around the wall of the barroom. Charley called to them, "You fellows all come up and have a drink on Injun Dick."

They all came up and had a drink, and Russell gave

Norris the Injun's gun and knife. That paid for the drinks. Then I bought one, and the barkeeper told everyone to fill them up again. Charley and I went out, put our hosses on good grass, and trailed down to the steamboat. It was getting ready to pull out. There were twenty painted ladies on board, all dolled up with their hair cut short. Charley said they were from his home town in St. Louis. Women would go up to Fort Benton and raise hell in the dance hall all summer, get what silver the cowboys, bullwhackers, and trappers had, and when the last boat went down the river in the fall, they'd be gone. They were a tough looking bunch, but Bill Massey was always a good friend to the dance hall girls.

We went to the barroom, and Charley bought one more for the boys, but Injun Dick had redeemed his knife and gun, and faded away. Norris told us that before Dick left he said he was going to get Tuck and Russell. I bought one more drink, and that made us brave so we weren't afraid of the thieving half-breed. Norris gave us another drink, and then we weren't afraid of anybody! We put up our tepee, and camped for three days.

The last we heard of Injun Dick he was decorating a cottonwood tree on Cow Island. The Vigilantes had hung him up to dry.

Charley and I bedded down early that night, at Clagett, and got up early the next morning to make a few high dives into the Judith River and wash our sins away. We lay around until noon, cooked the big feed, smoked, tied the flaps on our tepee, and went over to

the store. In front of the store were lots of pack and saddle hosses tied to the ground. Picks and shovels and gold dust pans were tied to the pack hosses.

Russell said, "Tuck, maybe here's a chance to sell some of our ponies."

We walked into the saloon. Fifteen gold hunters from the Black Hills were lined up at the bar. They had plenty of money on them. Dick Rowe was their leader, and he asked Charley and me to step up and have a drink. Bill Norris told them we were just in from the Little Rockies. I told Dick there was plenty of wood and water on the range, but I didn't know about the gold; we were cowboys, not prospectors. The men were all clean, fine fellows, and had a good outfit. They put their tepees close to ours, and camped with us while we were at Clagett.

We sold them all our Injun ponies except the mare that had the colt. They paid us thirty-five dollars a head, in gold. When I split with Russell, he said, "We're getting to be hoss merchants!"

On the fourth day we rolled the cotton, and hit the trail for the Judith Basin round-up with our pockets full of money and our bellies full of likker. Forty dollars a month wasn't much money, but we made up for it in fun, and the life suited Russell.

We trailed up the river till we came to old Jim Crawford's shack. This old buck used to be a "Diamond R" bullwhacker, but he quit the game and bought himself a yoke of bulls and a wagon. He took up a homestead on the Judith. We were old friends. He had been on this homestead two years, and had quite a pasture

fenced with poles. There were thirty head of cattle in the pasture.

"Where did you get the cattle, Jim?" I asked.

"Hell, Tuck, didn't you know I had a yoke of bulls to draw to?"

Jim was no rustler, but he was a good cow man. One night the Vigilantes put a brand on his door — 3777 — that meant get off the range and stay off.

We spent the night with Jim, and had six days left to get to the round-up, so we hit for Lewistown. The town was young, but it was a booming frontier place. Everything was hauled in by bull teams, and the old six-hoss stage brought in the U.S. Mail and the pilgrims. Gambling was wide open, with any game one could wish. The painted cats ran in herds, and a cowboy and his silver lasted quick in Lewistown. What money the cowboys and bullwhackers arrived with, the dance hall girls and gamblers got.

We trailed into town just as the lights came on. There were little bunches of cow hosses tied to the ground here and there in the middle of the dusty street. Charley said we better put our hosses in Dan Crowther's barn, and hang our saddles up. We could turn our hosses into the corral and let them eat hay, and when we got through milling around the dance halls and saloons we would have a place to unroll our beds and bed down for the night.

We two cowboys were empty, and our hosses were dry and hungry. We had lots of silver, and were intending to feed our hosses, and eat the best chow in town. We had made a long ride that day, and our

hosses were tired. We pulled off the leather, took off the packs, and hung everything up in good shape. Then we trailed across the street to the Silver Tip saloon. There were a dozen cowboys sitting around the wall, spitting cotton. They knew us, and Russell felt sorry for these cowboys. They were all broke. Russell bought a gallon of likker, and we all got down on the floor, sitting cross-legged, and cleaned up the gallon.

Every cowpoke told his troubles. They had soaked everything they had except their saddles — six-guns, chaps, spurs, lasso ropes — everything. All their belongings were behind the bar in soak, but Pie-face George and the Cowboy Prince were still in the lockup. These two had likkered up and started to smoke up the town. Old Bill Deaton, the sheriff, had grabbed them and put them behind bars. Fifty dollars for carrying concealed weapons!

The two boys in the lockup were special friends of ours. Russell got the boys together, and herded them down to the sheriff's office, fourteen strong. We rapped at the door. This old sheriff was hatched down in Texas, and he was sure hard-boiled. He opened the door in his shirt tail, and stood looking at us.

"What do you cowboys want, prowling around this time of night?"

Russell spoke up: "Now, Bill, we want those two cowboys you got locked up in your corral."

"I'll turn those two bad men out when you pay the fine — which is fifty dollars apiece for carrying concealed weapons and disturbing the peace."

I told the sheriff we had money to pay the fine, so he invited us into his office. We marched in. He sat down behind the desk. Russell said, "Bill, you write Tuck and me a receipt for one hundred dollars."

Bill said, "Now, Charley, you cowboys are all good friends of mine, and I'll cut that in two. That will be twenty-five on you, and twenty-five on Tuck." He wrote out two receipts, and gave one to Charley and one to me. Then he got his keys, and we walked behind him through a narrow chute till we came to an iron gate. The cowboys were sitting in a box stall. They had a candle burning, and both looked like their mammies were dead.

Old Bill Deaton unlocked the door. The cowboys stood up, and their spurs began to drag along the floor.

When we got back to the office the sheriff gave the cowboys their six-guns. I had a bottle of likker, and gave the boys a drink. I gave the sheriff one, too, and he didn't refuse. He gave us all a fatherly talk. Then we went down town and ate all there was in two Chinese joints. Sixteen strong we went to the Silver Tip saloon, and kept the barman busy till daybreak.

Charley and I didn't give the cowboys any money, but we paid all their debts. We didn't get drunk, we just had a good time. For three days Charley and I paid all the bills.

There were three kinds of cowboys: those that gave all their money to the dance hall girls, those that gave it to the gamblers, and those that drank it up.

9

A Race and a Rodeo

CHARLEY AND I had a good time in Lewistown. We paid all the cowboys' bills, and had plenty of money left. Dan Crowley told us a bunch of half-breeds over on Warm Springs Creek had a fast hoss, so Charley Russell and Billy Page, a hoss fighter, went over to see them. They dug up a hoss race to be run at the race track, at two o'clock the next afternoon. The Injuns had a race hoss, and I had only a cow pony, and the distance was to be a quarter-mile.

The next day the breeds were all on hand. They were working people, and owned a lot of land on Warm Springs Creek, and all had money. They put up three hundred dollars. Russell and I had more money than that, but we called their bet and bet one hundred dollars more with some gamblers.

Everybody in Lewistown was at the race track. The dance hall girls were betting their money heavy, and excitement was high. The half-breed's hoss was a trim-built slick, pure white. It was a very pretty hoss, and the girls were betting on it. The hoss lost. It was

fast, but not fast enough for my Bunky hoss. Russell said, "The gamblers and the painted cats will have to start all over again. They are broke. We've cleaned the town."

The bullwhackers and stage drivers all knew Bunky, and helped us trim the sporting element that day. I went to the butcher shop and bought a beef steer. "We will give these natives a banquet and a barbecue," I told Russell. "We will fill them up on their own money." The next day the cowboys had a real celebration.

The sheriff invited Russell and me to his office, and told us we had the town broke.

"You want to keep your buckskin hoss locked up, now," he said. Russell told him Bunky had been locked in the stable ever since the race. "I want all you boys to have a good time, tomorrow," the sheriff said, "but all your guns must be left behind the bar."

Charley and I saw we had the sheriff on our side, and we went the limit. We staged a Wild West show. We got our names changed to Mister C. M. Russell and Mister Patrick T. Tucker, and were the promoters. All the cowboys in the country heard about the show, and brought in wild steers and bucking hosses. There were Indians with war paint on their faces. Charley painted a picture of the wild cowboys and fighting Indians, and hung it above the bar of the Silver Tip saloon. In big letters above the picture he put

DAYS ON THE FRONTIER

The round-up wagons had come into town for fall supplies. Every cook drove his own four-hoss cook wagon, and they all had money. The next morning there were cowboys everywhere. We had a parade in the forenoon, with four hundred real cowboys. Every las' rope was going in the air as we trailed down the street ten deep. The street was only three blocks long. We came up another street where there were a few houses. As we turned the corner at one of these houses, a big fat black baby stuck her head out of the window. Russell and I were riding side by side.

"Fix a loop on that black gal," Russell said.

I did. I got my loop under both her arms. My rope was tied to the saddle, and my hoss pulled the big wench right out of the window. She dropped out easy, and Charley rode up to her and took my rope off her. "This is cowboy day, not ladies' day," we said.

Our next time down the street cowboys and wild Indians came whooping and yelling like savages. Loops were flying in every direction. The day was filled with action. Those hard-riding cowboys rode the wild hosses when they were drunk, and they rode them when they were sober, but no old-time cowpoke got up with his hands full of dust.

We put in two days at Lewistown. The first day we roped and branded. The boys always caught the calves by the hind legs and dragged them up to the branding fires. They were easy to handle that way. Hosses they caught by the fore legs, threw them, saddled them, and rode them to a finish. The next day we tried to sober up, but this couldn't be done.

A cowboy is used to long hours, so when he drinks he keeps long hours, too. In the morning we got ready to trail out of town. Charley Russell got out from under the canvas and stretched to his full height.

"Tuck," he said, "this butterfly life is sure hell."

We ate our breakfast, and Horace Brewster began rounding up his cowboys. We found old Bill Bullard fast asleep on a revolving gate. It was the gate back of the dance hall. Bullard had got into the gate, and gone round and round. When he found he couldn't get out, he lay down across it and went to sleep. When he woke up he thought he was night herding. Some cowboys get so sleepy on night herd they almost die, and Bullard was one of them.

At nine o'clock our cook wagon trailed out of town with the sick cowboys trailing behind. Charley and I were holding Bill Bullard on his hoss. The first camp, where the round-up was to start, was twenty miles away. Three miles from the round-up camp we came to a homestead where there were a few cocks of hay. We got Bill off the leather, laid him on the ground, and covered him with a pile of hay. But before we got to camp it began to rain, and rained all night.

Russell woke me early the next morning. We hurried to eat our chow, then saddled our hosses and took the back trail for Bill. He was still breathing, but he was soaking wet and only his feet were under the hay. His hoss had stayed close beside him all night. Bill was a good friend of ours, and one of the best cowpokes that ever trailed a herd. We gave him a drink of whiskey, and at that he woke up.

The next morning the captain of the Judith Basin round-up gave the boys a good, fatherly talk. Charley Russell was to wrangle the cow hosses in the daytime, while the rest of us got in the leather and rode circle.

We worked hard. In a day or so we had forgotten all about the butterfly life in Lewistown. We worked the Judith Basin and branded all the calves, and gathered all the bulls that were four years old or older. We cut them in two herds, trailed them to Billings, and shipped them to Chicago.

Charley and I went to the railroad, but we didn't go to the big city with the bulls. In Billings we milled around for two days, then packed our hosses and trailed across the Yellowstone River to the Crow camp. The Crow Indians were good friends of mine, and Plenty Coups and Little Bear were glad to see us. They had never seen Charley before, but they knew he was a great artist. When Charley was in an Indian camp he was just where he wanted to be. From the time he was six years old he had wanted to be in the West with cowboys and wild Indians.

Little Bear spoke pretty good English, and told us we had come to the Crow camp just in time to make the big hunt. Thirty young Indians and ten old squaws were going into the Pryor Mountains to hunt blacktail deer. This chance to hunt with the Indians hit Charley and me just right. It took the Indians three days to get ready for the trip.

The first night we were in camp they staged a wild war dance. Plenty Coups gave Charley and me a big buffalo robe to sit on, where we could watch the

dance. The Indians spent the entire day getting ready to stage their big feast and dance. They painted their faces and bodies, and wore nothing but breechclouts, full-feathered bonnets, coyote and wolf tails tied behind their backs, and brass bells on their ankles. As soon as the feed was over, the squaws built a big camp fire. One hundred braves began to mill around in a circle, single file. They would look up at the stars with a wild grin on their faces, and give their savage war whoop. It echoed from hill to hill. That was a wild night on the banks of the Yellowstone, among the cottonwood trees.

Charley and I and the two Crow chiefs sat on the buffalo robes until long into the night. We smoked and kept tanked up on Java. The longer those Indians danced the wilder they looked, and the more piercing their war whoops grew. The sweat ran down their naked bodies. The old squaws sat around the outside of the circle, humming their mournful songs.

Charley sat studying every movement. He overlooked nothing. He fixed his eyes on the dancing Crows and studied them as he had studied the Indians fighting and buffalo hunting, or trailing through the foothills with their travois in single file.

The morning star was beginning to sparkle in the far east when Charley went to the tepee we were to have during our stay with the Crows. There were plenty of buffalo robes there for us to bed down in. I slept until 'way in the afternoon, and when I rolled out Charley was already up. He was sitting by an old cracker box finishing a painting of the war dance.

The picture was two feet square. I went and brought Plenty Coups and Little Bear. Plenty Coups took Russell by the hand and said, "Heap good!" He took the picture to his tepee and put it on display, and all the Indians looked at it as they filed past.

In every tribe there is a buck Indian who paints pictures on Indian tepees, but Charley painted some real pictures on the Crow tepees on this visit. The Crows said he was related to the Great Spirit.

We were in the Crow camp three days, and they killed a good many fat dogs for our benefit. Charley didn't like the dog meat, but I ate it to be friendly. The fat dog feast is a great treat to Indians.

On the fourth morning Charley and I and the Indians rolled the cotton. The old squaws took ten travois and lashed on the camp outfit and bedding. Everything was ready, and about ten o'clock two cowpokes, thirty braves, and ten old squaw cooks trailed for the high country in the Pryor Mountains.

An Indian doesn't hunt like a white man. When he gets into the game country he goes where the deer feed, and sits down in some bushes. He doesn't run the game out of the country, but sits and waits. When a deer comes out to feed, he shoots it. The Indian sees the deer, but the deer doesn't see the Indian. If a white man's wife were sitting in the brush waiting to shoot a deer, her dear would come along and shoot her. An Indian never takes a shot at his squaw when he is hunting. When a buck Indian shoots a deer, he makes a hole in its neck with his hunting knife and lies

down and sucks its blood. All Indians do this, and many old-time hunters.

High up in the Pryor Mountains we camped at a spring close to an open park. The squaws cooked a good meal, and we bedded down early. Near midnight I heard something tramping in the mud around the spring. I got up and looked out of the tepee. On the hillside above the spring stood a blacktail buck, broadside, looking down at our camp. The buck Indians were all great hunters, but it was I who played in luck that moonlight night on top of the Pryor Mountains. I reached back in the tepee and got my old forty-five ninety, and came to the split in the tepee. The buck was still standing broadside. I cocked my gun, got a bead on this moonlight visitor, and the gun cracked. Charley was down on his hands and knees looking out. "You got him, Tuck," he said. "That will be a joke on the Injuns."

Plenty Coups was the first to come to our tepee. He saw the big buck kicking his last, so he went up and cleaned up on his blood. By this time the Indians and squaws in camp were up and ready for action. The squaws started a fire, put on the big coffee kettle and made coffee. The Indians did to the blacktail deer what the cowboy did to the watermelon — they ate him raw.

They gulped it down. Then we smoked, and Plenty Coups and Little Bear told some great hunting stories.

In two days we shot eighteen fat deer and snaked them into camp. Indians do not hang up their meat as

white men do. The Crow squaws skinned the deer, cut the paunches out, and cleaned them. They prize the deer paunch highly. They cut the wild meat into pieces and piled it on deer skins. The third day when we got to our camp more Indians were there, who had come up from below for the deer meat. They camped with us one night, and the next morning packed all the venison on travois and trailed down to the main camp.

The squaws did all the work. All the Indians were happy, for Indians are always happy when they are mixed up with plenty of raw meat.

Charley Russell was having a fine time in the Crow camp. We stayed in the Pryor Mountains six days — not many groceries, but plenty of game.

The last day we hunted, two Indians came bringing a young black bear into camp. They had run him up a tree, and one of the bucks climbed the tree and tied buckskin thongs to the cub's feet. When they got back to camp they untied him and let him run. All the Indians in camp stampeded after the bear, bucks and squaws tumbling over each other, with the little black bear taking the lead across an open park.

Russell and I laughed till we could hardly run. The Indians were whooping and screeching. The bear hit the tall timber and climbed to the top of a tree, still reaching for more limbs. Charley's legs were longer than mine, and he got to the tree first. The Indians were milling around under the pine tree, and the poor baby bear was so scared he got rattled, let loose

of the tree, and came tumbling to earth. The Indians were making more noise than a thunderstorm.

When the cub hit the ground he was mad, so mad he was jumping up and down. An old bow-legged squaw threw a blanket over him, and that made him fighting mad. He tore the blanket to shreds. Plenty Coups grabbed the bear by the hind leg, and a squaw wrapped a blanket around the bear's head. The little fellow gave up the fight then, and Plenty Coups was the big chief and hero.

This is the kind of sport Indians like, and Russell and I enjoyed the bear hunt. Russell said he had had more fun that summer than in all his boyhood days in St. Louis. I told him the fun with the bear hadn't begun yet; that when we got back to the main Crow camp the Indians would turn the bear loose, and let the young Indian boys run the cub down.

The next morning the bucks got on their ponies, leaving the squaws to pack the meat on their travois. They hog-tied the little bear on a travois. We trailed out of the mountains single file. The Indians were feeling good, for they were filled up on deer meat.

After the hunt was over, and the squaws had got the meat to camp, the real work of drying meat, tanning buckskin, and making moccasins began. The children had their share to do. Plenty Coups loved children. He had none of his own, but he loved them just the same.

One day he got all the little Indian boys and girls together, tied a rope to the cub bear, and turned him

loose. The little fellow had been full fed, and it was fun to see him trying to get away, with the young Indian boys and girls wrestling him. Plenty Coups and the bucks and squaws liked to see young children in action.

Charley painted the dead deer with the Indians around it. He painted the Indians stumbling over each other in the wild chase after the cub. He painted hosses, buffalo, deer, and all manner of things on the Crow tepees, and wherever Charley went Indian children would be following at his heels.

After Charley got the Crows' camp decorated with pictures they put on a war dance. The night of the powwow we were to eat the young bear. I told Little Bear and Plenty Coups that we had had a good time in their camp, and that we were going back, now, to our own camp on the Judith.

Plenty Coups said, "No. We make big Injun fight." That meant that they were going to put on a sham battle.

We stayed and saw the fight. The Indians got up early the next morning, and began putting on their war paint. The great Crow warriors got their ponies ready, and put eagle feathers in their manes and tails. One hundred warriors, with eagle feathers blowing and twisting in their war bonnets, paraded up and down in front of the camp four or five times. Plenty Coups and Little Bear each took fifty braves and rode out from camp a little way. When they were a half mile apart they turned and came on at a fast gallop, whooping and yelling as fighting savages would. As

they came closer to each other they began to shoot. They were using only powder, not bullets. Indians tumbled off their hosses and hit the ground, dying and kicking, while the ponies milled around. This wild sham battle lasted an hour.

Russell said, "Tuck, they make it look like the real thing."

Plenty Coups won the battle. The old squaws busied themselves taking care of the dead and wounded. Then the show was over. We had another big war dance that night, and the next day Russell put in the entire day painting the sham battle. The Crows went wild over his picture.

In the morning Plenty Coups gave orders to have all the ponies rounded up. He told Charley he had nothing to give him for his pictures but ponies. Charley told the great chief he didn't want anything for his pictures, but Plenty Coups said his people liked them, and unless Charley took some ponies he would be angry.

Charley told the chief he didn't want to see him mad, and Plenty Coups took Charley by the hand and they had the big handshake.

Out from camp the braves were holding two hundred ponies in a tight bunch. The hosses were all gentle. Charley and I went out to the hoss herd. I dropped my loop on a buckskin, and Charley spread his on a black pinto. We tied them to cottonwood trees. Plenty Coups came out, dragging a rope. He went into the hoss herd and dropped his loop on his war hoss, a rangy blue pinto. Russell got fooled — he

thought the chief was going to give him his war hoss, but I thought different! Plenty Coups caught the war hoss so we shouldn't put a rope on him.

Plenty Coups knew the good hosses better than we did, and pointed out two smoky-colored ones to us.

"Those are brothers," he said, "and good cow ponies."

Chief Plenty Coups was one of the best Indian hoss-men I have ever seen, and I've seen plenty of Indian riders. When he wanted to break a wild hoss he didn't lash a buffalo hide to it, and let it wear itself out bucking, as most Indians did. No, sir, he threw a loop on the hoss and got in the middle of him, and rode Mister wild hoss to a finish.

When we rolled our bedding to hit the trail for Billings it seemed as though all the Indians in Montana were in the Crow camp saying good-by to Charley Russell and giving him presents of dried deer meat. He had won a home for himself in that Crow camp!

God's Country

THE INDIANS HELPED Charley and me pack our hosses. Plenty Coups and two of his subchiefs trailed to Billings with us. Charley found a letter waiting for him there from his mammy in St. Louis. She wanted him to come home to spend Christmas day, and sent him money to buy a ticket. Charley's mammy was like a good many other boys' mammies, she wanted her boy to come home and stay away from wild Indians and shooting cowboys. But Charley loved the West. He loved to ride the high country, and look down and see Indians chasing buffalo, riding bareback on their fast-running ponies. He liked to camp in a lonely spot. The rougher the country, the better Charley liked it. He cared for everything in the West — the birds, the wildflowers. Many a time, when wild roses were in bloom, if Charley and I were riding up a lonely draw, he would stop his hoss, get off the leather, and pick a bunch of wild roses. He was tender-hearted, and good to all animals, and one never saw him jerk the devil out of his hoss if it was tired and

stumbled with him, as some of the cowboys did. He liked the West, and didn't want to go back to St. Louis.

There were twenty-five cowboys in Billings when we got there, all broke. It was different with Russell and me, we had plenty of silver. The fourth day we were there a Montana blizzard struck town. It snowed three days. Wind from the north piled snow in big drifts. Some of the cowpokes were getting lank, and Russell and I fed them at a Chinaman's place. Nine of these boys had punched cows for the Custer Cattle Company, and for a man named Paul McCormack who was a big owner in the company.

The Chinaman who owned the restaurant died — a gun slinger gave him a pill in the stomach that he couldn't digest. He carried his money in his belt, and cowboys weren't all angels. Some of them would knock any Chinaman over for his silver.

The restaurant had to be sold, so Russell and I went into the real estate business. We invested in fixtures, chairs, tables, tin plates, cups, and what groceries there were in the shack. I went to Paul McCormack and told him his cowboys were broke and going hungry. He told me to bring them to his office. We rounded up four of the Custer Cattle Company's cowboys, among them Crying Bill, and trailed back to the cattle king's office. Russell was with us this time. He wanted to hear Crying Bill give McCormack the big talk. When Crying Bill got to talking and crying, old Paul loosened up. He told us we could have what beef we wanted if we would go across the Yellowstone River to get it.

We went out of his office happy. Russell hunted up Charley Rivers and told him about the deal. Rivers was an old-time round-up cook. He promised to cook for the gang without pay, just for his eats during the winter. We saw business was going to be good, so Russell painted a sign:

GOOD EATS FOR FOUR BITS A MEAL
FOR MEN ONLY
TUCK AND RUSS COMPANY

Russell and I went to Yegen's store, and told Yegen Brothers our troubles. We didn't cry, we just talked plain English, but the Dutch brothers got kindhearted and donated one hundred dollars' worth of groceries. Next we went to see Mr. Babcock. He was a big hardware man, and owned our place of business. It was a biting cold day, but a good day for begging. I made the talk, and Mr. Babcock wilted. He gave us the rent of the cookhouse free.

That night Charley and I rounded up all the cowboys. We had a meeting at the new eating house, at nine o'clock, sharp. We elected our officers: one manager — that was Russell; one man to take care of the silver — that was me; one flunky — that was Crying Bill. When the meeting was over we had a midnight supper, and then went to the bunkhouse — The Dark Hoss Livery barn — and bedded down for the night. It was thirty degrees below zero, but we cowboys had plenty of blankets and slept warm.

The next morning Charley got on the good side of the cook by telling him he was going to buy him a

Dutch oven, and dig him a bean hole behind the cook shack.

"Okay," the cook said, "you are a good manager."

At noon we had thirty for dinner, twenty star boarders and ten throw-ins, so we took in five dollars in cash. That night we had a bunch of painted cats, but they came in at the back door. There wasn't any sign on that door, so they couldn't be put out. They were good sports, and paid for their meals.

This eating house of ours was run on strictly religious principles. When the business got on a paying basis, Charley put the cook on the payroll. This old trail cook was an artist at cakes and pies, and a king among cooks.

The Custer Cattle Company boys packed lots of fresh meat from across the Yellowstone, and we did a good business and were getting along fine; but December 17, Charley got another letter from his mammy begging him to come home. That letter made Charley homesick, so we sold out the eating house to a Frenchman. We hadn't made any money, but we had made lots of friends.

Russell packed his war bag with Indian curios, and that night he hit the iron trail for St. Louis, to be gone a month. I was to take good care of his hosses till he came back.

The night he pulled for St. Louis it started to snow, and snowed for two days. We got a real Montana blizzard, forty degrees below, and that was where I missed my bed pal. When I got out from under the canvas the morning after Charley left, I found the

letter his mammy had written him begging and pleading with him to come home, and tears came in my eyes. I could remember clear back to the time when I was four years old, and my own mammy had died.

All the boys missed Charley, because as long as Charley had money the boys could eat and drink. Charley never gambled and wouldn't stake any of the cowboys to play; but ninety per cent of the old cowboys did gamble, and they wouldn't be in town two days before they'd be broke.

The days passed along, and the weeks, and no letter from Charley. I went to the post office every day, but no letter came.

Some of Russell's pictures were tacked on the walls of Potter and Vail's saloon. Potter and Vail were ex-cowboys, and their place was headquarters for the cowpokes. They knew how to get the boys' money, but money or no money a cowboy could always get a drink there.

Charley Russell never went broke. If he ran out of silver he would paint a picture and sell it for five or ten dollars, or he would take a piece of chalk and draw a picture on the saloon floor. When he had drawn the picture someone would buy a drink for the house. Russell didn't want money, all he wanted was a good time. He liked to see everybody happy, and hated quarreling. He stopped many a row by saying, "Come on, boys, have a drink, and call it off." But if he didn't like a man, he didn't like him, that was all. He had more friends on the cow range than anyone else I know.

Five weeks rolled by, and then came a letter from Charley. He said his mammy didn't want him to come back till spring. He wrote:

"She says, 'Charley, you'll never do anything but paint pictures, anyway, and you can't sell them unless you learn to paint in the background,' so I've made up my mind to do as she says, and go to school for three months. You better stay in Billings until spring, and take good care of the hosses."

When Charley left me he gave me one hundred dollars to pay for the hoss feed and have something on hand for him when he got back.

We missed Charley. I got sick and tired of lying around Billings, doing nothing. I wanted to get away from the smell of likker and the noise of poker chips. The cowboys were all broke, and begging me for money to eat on.

One day Tony Loftus came riding into Billings. He had a shack four miles down the river. Tony was a real hoss fighter. That was all he did, handle hosses. He had a bunch of wild ones that he was breaking to ride. Tony and I took my hosses and Charley Russell's down to his winter camp and turned them loose on free range. Once a week I rode into Billings to get the mail, and got a letter from Charley every time. He said he was dying to get back to God's country. The last week in March I got a letter saying, "Tuck, I'll be in Billings the first day of April, and I'm not fooling."

The first day of April we got up at daybreak and trailed into Billings. The train came in at ten-thirty, and Charley was standing on the platform with a wide

grin on his face. He had lots of baggage, mostly pres-
ents for his cowboy friends. He shook hands, and
asked me how Monte was — Monte was his pinto hoss.

I said, "Charley, Monte's right across the street,
looking this way."

Charley broke away from the dry cowpokes.

Monte hoss knew him. I had put Charley's saddle
on the old cow hoss that morning, because Charley
had said he was coming and I knew he would come.

Charley looked like a drug store clerk. His leathery
face had lost its color, and he looked white.

We milled around Billings for a time, and then went
down to Tony Loftus's place and stayed two days. The
third day we got our hosses in from the range, rolled
the cotton, and started for the Judith Basin.

The grass was showing green on the sidehills. Water
was running in the "dry" gulches, and snow in the
mountains was melting fast. The spring calf crop was
good. We could see cattle everywhere. Charley's eyes
were on everything.

"Montana is good enough for me!" he said.

At Lavina we camped two days with some cowboys
who had wintered there, and went on to Judith Gap.
It was a two-days' trail to Al Stevens' stage station. At
Al's place were eleven cowboys heading for the Judith
who figured on riding the bag line until the round-up
opened, May fifteenth. Al Stevens bought us a drink,
then Russell bought one, and we bought a lot more.
We were having a good time, because Russell and I
were glad to see the old gang.

When the overland stage rolled up at midnight, and

Billy Coles put his foot on the brake staff and the wheels began to skid and the stage came to a stop, we were all out milling around to see our friend Billy.

He looked at us.

"Boys, a bunch of breeds held me up, back on Antelope, and got the little green box."

11

Breeds and Babies

WHEN WE HEARD that Billy Coles had been held up and made to hand over the little green box we all went back into the barroom and took a drink. That made us brave. We had a meeting and elected a captain, a freckle-faced, bow-legged Texas cowboy. This old leather-face was lightning with a six-gun. He was a seasoned trail boss, and a born man-hunter. His name was Bill Ruff, but we always called him Rough Bill.

At the break of day the next morning there were thirteen wild cowboys in the middle of their cow hosses. This was Charley Russell's first man-hunt. He was ready to go, for he loved action and adventure. He said that down south, where he was hatched out, if the people had anything against a man they put him in for sheriff. Then he either materialized or lasted quick.

We were hard-riding, hard-shooting cowboys. There were no iron bars for a thief to look through in those days, just a rope and a chance to look at the sky.

Some of the outlaws died game, and some wilted and cried like babies when they felt a rope around their necks.

We trailed to the spot in the road where the stage had been held up. The season had been wet, and it was easy to trail the stage robbers in the soft ground. Their hoss tracks were plain. We took their trail straight for the Snowy Mountains. The trail went up into the jack pines, then turned and went east around the mountain side. We worked around to the head of Flatwillow Creek, and came to a spring on the mountain side. Here the robbers had made a fire, boiled coffee, and had a meal.

They had nine hours' start of us. Their trail went down Flatwillow Creek four miles, then turned to the left, up and over the benchland. The outlaws were headed for the bad lands and the Missouri River.

We trailed these devils thirty miles north, and got into the brakes of the Missouri. As we were trailing along down a creek the tracks of six hosses showed, instead of three. Three others had joined the gang. The trail left the creek and turned up over a hill. When we came to the top of the hill Russell saw smoke ahead of us. We got down off the leather, tied our hosses to the ground, and went easy to the brow of the hill. It was growing late. The sun had gone down. We could see the camp fire three miles down the creek in some cottonwood trees. On the sidehill, close to the camp fire, we could make out ponies feeding on the bunch grass.

Old Bill, our captain, told us we had better drop

back on the creek. "That fire is sure the robber's camp," he said. "We will camp on the creek, and round those half-breeds up at daybreak."

We didn't make any fire. We had jerked meat in our saddle pockets, so we ate jerked meat, drank water from the creek, and when we bedded down took the saddles from our hosses for pillows, and covered ourselves up with our wet saddle blankets.

Bill Bullard stood guard till midnight. Frosty, an old cowpoke, took the last relief. He wakened us long before daybreak. We rolled out, madder than hornets. We put the leather on our hosses and looked our guns over good. The captain gave us our orders. Russell and I were to take six men, go below the robbers' camp, and ride up the creek. Bill Ruff was to trail down the creek.

We were coming close to the half-breeds' camp, and day was just showing, when Bill fired the first shot.

We put spurs to our hosses and made the wild ride. When we got to the outlaws' camp the other boys were right there. We surrounded the thieves. They were lying in the long rye grass, and when they rolled over and got to their feet they were looking into guns. Three breeds reached for the sky. One hard-looking old squaw stood up and made the big war whoop, and a bow-legged breed got brave and reached for his gun. Bill Bullard's gat spit fire, and the breed had only one hand left. The blood was dripping from his arm.

Rough Bill said, "Frosty, you and Blacky take the cutthroats' guns." When this had been done we got down off the leather and hogtied the fighting squaw.

She was the one who was packing the grub and bedding for the outfit, who had joined them at the head of the creek.

The captain was hungry and mad. "Let's get through with this necktie party, boys," he said.

In less than ten minutes there were three half-breed hoss thieves at the end of lasso ropes hanging in the cottonwoods. The sun was just peeping in the east.

The squaw was the mother of two of the breeds that we hung in the brakes of the old Missouri. We went through her pack outfit and found some groceries. We were hungry. We found the treasure box, too. The outlaws had tried to break it open, and had battered it out of shape, but it was still locked.

After we had filled up on the half-breeds' groceries old Bill turned the squaw loose and told her to go to her camp and tell her people what had happened. She made no sign of moving, so we left her there and got into our saddles to take the back trail.

At the foothills of the Moccasin Mountains we came to a ranch house close to the Maiden road. A man came running toward us, waving his hand for us to come to him. We turned our hosses, and when he came up to us he told his story. His wife and he had been putting in garden, and their little five-year-old girl had been playing near them along the creek. When they went to get her, she was gone. She had been gone two days, and the mother was almost crazy.

When it came to women and children our captain weakened. He told us to scatter out and try to find the

baby. Charley Russell and I trailed down the creek on a well-beaten trail, and when we had gone about a mile we could see the little girl's tracks in the dust. We trailed her three miles. She had quit the beaten trail and hit for the hills. We rode to the ridge. Charley saw a band of sheep two miles away grazing along the side of the Moccasin Mountains. We got off the leather, and I got out my field glasses from my saddle pocket. I could see the herder and his dog and a little girl sitting in the shade of a jack pine.

Russell said, "I can see the little girl without any glasses."

Charley and I hightailed it over to the band of sheep, and this is what the sheep herder told us:

"The other night when I was driving my sheep to camp, my dog found this little gal cuddled up asleep in a bunch of sagebrush. I picked her up and carried her in my arms to my camp. She was still asleep, and didn't wake up until along in the night. I had put her to bed in my bunk. When she waked up she called for her mammy, and cried for a long time. My dog outside the tent he would bark and cry when she cried. Finally she told me she was hungry. The poor little gal was starved. I had some canned milk and sourdough bread, and she filled up on bread and milk. She was so tired and sleepy I put her back in my bunk. In the morning she got up when I did, and said she was hungry again. So I filled her up on flapjacks."

This good old sheep herder hated to part with the baby, but Russell told him we had to take her to her mammy. Russell liked little folks, and wanted to carry

her, and I said it was okay with me. Charley got in the leather and I handed the baby up to him, and the old sheep herder began to cry. The dog cried, and the little gal cried, and we rode away. Russell and I felt bad, but we didn't cry. Pretty soon Charley was telling the baby funny little stories, and had her laughing.

The baby's mother saw us coming and ran out to meet us. Her long black hair was blowing loose, and tears were streaming down her face as she reached up and took the baby. If you want to make a friend for life, bring back to a mother her baby who has been lost.

"Don't cry. I'se all right," the little girl kept telling her mother.

When the hunt for the child started the captain had left Bill Bullard at the rancher's cabin to close herd the little green box. Bill had taken the saddle off his hoss, and thrown the saddle blanket over the treasure box. We didn't know how much was in it, but Bill had his saddle blanket over it and was close by it, not asleep.

After the little girl had told her mother all about the sheep herder she went to sleep. Then the rancher and his wife began to get busy. They cooked up the big feed for us. The young woman was from Missouri, and knew how to make hot biscuits. She dished out ice-cold milk from the springhouse. Some of us hadn't eaten a woman's cooking since we left home, and this Missouri gal enjoyed watching us fill up.

The next morning while breakfast was cooking Charley Russell drew a picture of a little girl and a dog

and an old man sitting under a jack pine. He tacked it on the wall of the cabin.

After we had eaten breakfast we lashed the little green box on one of the ponies we had taken from the dead breeds, put the leather on our hosses, and trailed to Maiden. We had a few drinks there, and ate dinner at a Chink joint while we let the hosses feed for two hours. Then we hit the trail for Lewistown, and got there just as the lights went on in the big dance hall. The town was full of wild cowboys, harmless, drinking and having a good time before the spring round-up should start.

We took our treasure box to the post office. The postmaster told us there was $15,000 in the box, with a reward of $1000 on it. We had to sign a paper and have it sent to headquarters before we could get our money. The next day Charley drew a picture of the three breeds hanging in the cottonwood trees, and it went to headquarters with the letter.

In two weeks we got our reward.

We milled around Lewistown two days before trailing for Judith Gap. Al Stevens asked our captain what we did with the stage robbers, and old Bill said we put them where they wouldn't hold up any more stages. Al gave us each a drink, and we bought a few more. We laid over one day at Judith Gap, and there Charley Russell painted a real picture of the stage robbery. Mr. Stevens slipped him ten dollars for the picture, and Charley said, "Drink up the ten, boys," and it lasted quick.

Bill sold the three ponies we took from the stage

robbers to some prospectors for one hundred fifty dollars. He divided the money among us cowboys, and we each had a little silver then. During the three days we stayed around the stage station Charley was drawing pictures of the hold-up, the hanging, and the little gal and dog and old sheep herder. Mr. Stevens paid him twenty-five dollars for the three pictures.

Charley was never idle. He was always painting pictures, and most of them he gave away. He could tell a story, or paint it, true to life.

We had a good time at Al's, telling stories of our adventures and all the fun we'd had. None of the old-timers could beat Russell at storytelling, and the gang was never complete without him.

The third day we rounded up our hosses, rolled the cotton, shook hands with Mr. Stevens, and hit the trail for the home ranch of the Iowa Cattle Company. That was where the cattle kings and the cowboys were to meet for the spring round-up. On our way to the Basin we camped at Ubet, a stage station run by a woman. Her name was Alice Barrows. We had our midday meal with Mrs. Barrows. She was a wonderful cook, and a mother to all the cowboys. One of her sons, Dutch Barrows, was a well-known cowboy who worked for the D H S outfit.

When dinner was over and the cowboys were sitting around smoking, Mrs. Barrows came out to the barn with her apron over her head. She informed us she was going to give the cowboys a blowout and a big dance. The only women in the country were three old married women and one red-headed schoolma'am.

The schoolma'am had come west to land some big cattle king. She was as pretty as a mud fence, but she had lots of admirers because calico queens were scarce in early days in Montana.

On the dance floor this fair young schoolma'am got her loop around an old cowboy who claimed he had lots of longhorn cattle but hadn't branded any of them yet. This young schoolma'am close herded the cowpoke until after the marriage ceremony.

We camped in Ubet for the wedding. None of the cowboys got mad. They all really liked the girl, but she had red hair and a high temper, and Squeaky Joe, her husband, had been in the matrimonial business before.

They lived together one moon, then the cowboy went back to Texas for his big herd and forgot to come north again.

Russell could sure put the velvet on this romance. He often told the story of the red-haired gal and the slick cowpoke. He said she got up, one morning, and her cowboy lover was gone. She went to the hoss barn to look for him, but his cow hoss and saddle weren't there.

Our winter fun was over. We rolled the cotton, said good-by to the Ubet barroom with its smell of likker, shook hands with Mrs. Barrows, and hit the trail for the Judith River.

12

Brands and Buffaloes

ALL THE OLD-TIME cowboys put on too much tallow during the winter months. They got logy, that is, lazy. When the days got to be one hundred ten in the shade and there was no shade, and the boys had to take long rides and wrestle the big bull calves, the exercise worked off their surplus tallow, and they began to smell like men instead of like barrooms.

When we got to the home ranch of the Iowa Cattle Company all the cowboys were there ready to ride. Mike Ryan, the great pastry cook, had been in St. Paul all winter getting a belly on himself drinking beer. He was the best round-up cook I ever knew, and I don't stutter when I say it.

The second night in camp the cattle men held a meeting, and my old pal Russell and I were elected by a big majority to "rep" on the Shonkin range. A rep is one notch higher than a common cowboy, and gets ten dollars a month more. To be a good rep one has to know brands. What he has to do is to look through all the big herds that are rounded up on another range,

and have all the outside cattle trailed back to their own ranges that he is representing. A rep is a high-toned cowboy, and is supposed to know all the different brands.

The cowboy artist and I got ready to rep on the Shonkin. We rolled our cotton and packed our hosses. I had an old fiddle that had been all over cow land. I put the fiddle and my war bag on top of my bed roll, threw a squaw hitch over the pack, and was ready to hit the trail. Russell had a paint box on top of his roll. He gave his pack the squaw hitch and we were off. We had twelve picked cow hosses apiece. We represented twenty-eight different brands. There were 86,000 head of cattle on the Judith Basin range that year.

It was May tenth when we started for the Shonkin range, sixty miles northeast. We trailed along the benchlands until we came to Arrow Creek, along in the evening.

Two trappers had a shack of cottonwood logs right on the creek. One of the men was French. We intended to camp with these trappers. When we came up the Frenchman was cooking his supper outside the cabin. I asked Frenchy why he was doing his cooking outside.

"My partner, last night he die," Frenchy answered. "He never do tat way before."

I questioned him about what had happened to his old pal. He and Jim Dowe had been partners for years.

"We go bring all trap to camp," he told me. "Jim gets to shack first. When I come, Jim is seeck like hell.

He eat the belly full of sour beans. I can do not'ing. Pretty soon he say 'Good-by,' then he keeck a little while. Then he is die. He is lay on his bunk, so I cook my supper outside."

Charley said, "Tuck, we better investigate."

We got off our hosses and went into the cottonwood shack. Frenchy didn't say anything, but he looked scared. Old Jim was dead, lying on his bunk with his clothes on. He was all puffed up, and we could see where he had been eating beans out of a Dutch oven. They had been cooked too long, and had soured, and were like so much strychnine.

We camped all night with old Frenchy, but we didn't bed down in the cabin — and we rolled out early the next morning.

Charley said we had better bury the Frenchman's old partner. We went up on a little hill, and dug a big hole. The Frenchman didn't help. He walked around talking to himself. We knew he felt bad, so we didn't try to say anything to him.

When we had finished digging the grave we went back to the cabin and got the dead trapper out of his bunk. We rolled him in canvas. He was stiff as a log. I took his feet, and Charley took his head, and we packed our burden slow and easy to its last resting place, a little knoll under a cottonwood tree on the bank of Arrow Creek. We lowered him into the grave, and when he hit the bottom we took off our Stetsons.

The cowboy artist knew a few prayers. He looked up at the sun and proceeded to pray, but his prayers

didn't last long. The old Frenchman was praying and crying all the time.

We rolled boulders on to the trapper's grave, so the wolves and coyotes couldn't scatter his bones. Charley and I felt bad, but we had done our duty. We rounded up our cow hosses, put the packs on, saddled our hosses, shook hands with the crying Frenchman, got in the leather, and hit the trail down Arrow Creek.

The stage road crossed the creek, and just as we got our hosses strung out along the road, here came the stage over the hill.

Billy Coles, the driver, knew us. He put his foot on the brake, and the wagon came to a stop. There were six passengers on her. They thought we were holding them up, and came piling out and reached for the sky.

Billy laughed, and told the pilgrims we were only innocent cowboys and all we wanted was whiskey. One of the drummers had some likker in his grip. Billy Coles, Charley and I laughed and talked together until we had drunk up all the drummer's supply. An old man and his wife were among the passengers, and the woman kept telling her husband that as soon as we were drunk we would shoot them.

As we trailed along old Square Butte, after leaving the stage, we saw lots of rattlesnakes. We didn't care, now, because we had likker under our belts.

That night we camped on the Ike Kingsbury ranch. His name in the States was Adkin W. Kingsbury, but it got changed to "Ike" on the range.

Kingsbury was the cow king of the Shonkin. He had

a Chinese cook whose pigtail was as long as a bull-whacker's whip. There was no calico on this ranch, just men, earmarked for cowboys. Mr. Kingsbury told us the round-up would start at Lost Lake. He had nine cowboys working for him that he had brought from Texas. As we were around the fireplace that night sitting cross-legged, smoking, Mr. Kingsbury told a story on one of his long-legged cowpokes.

"When I took up this ranch," he said, "I had to do a lot of building. I had to build the log house and the bunk house, and have poles cut for the corrals. I went to Fort Benton and bought axes and crosscut saws, and the next morning rounded up the boys and told them to go to the mountains and get out logs and poles. One bow-legged cowboy drawled, 'Mr. Kingsbury, kin you cut them poles a hossback?'

" 'I'm afraid you'll have to do it afoot,' I said.

" 'Mr. Kingsbury, I guess I'll blow south,' and he did."

In the morning we got up at daybreak, washed in the creek, and milled into the chuck house. The Chink cook had a stack of flapjacks two feet high, but by the time the cowboys had filled their plates there were none left. A Chinese cook always provides plenty of chow.

After breakfast we took a smoke, and put our bed rolls on our hosses. Ike Kingsbury was an old man, but he was still a real cowpuncher. He put his bed on his hoss and got ready to go with the boys. He left one old cowboy at the home ranch with the cook. This boy had one wing off. He had had one arm shot off when

he was a Texas Ranger down on the Rio Grande, but he could still throw lead with the other hand. His name was Tex, and Mr. Kingsbury left him at home to close herd the ranch.

It was a nice May morning, and there were birds and flowers everywhere. The sun was just peeping in the east as we got into the saddle ready to ride. We had to go fifteen miles to Lost Lake, and we got there just as the cook hit the dishpan for chow.

Charley said, "Boys, there are three things I love to hear: the old dishpan banging for chow, a coyote barking, and a wolf howling."

Tom Martin was captain of the round-up. On the morning of May 15 he scattered his boys on the foot-hills. Arrow Creek was the line between the Shonkin and Judith Basin round-ups.

The first day the Shonkin boys rounded up four thousand head of cattle. Russell and I cut over three hundred head of Basin cattle out of this bunch. We branded the calves, and the Shonkin boys then drove these Basin cattle across Arrow Creek. The next morning the cattle showed all the different Basin brands on them. Russell and I were getting along fine and making a big round-up. The cowboy artist was getting to be one of the best brand readers on the range. Sometimes there would be a disputed brand. The cow or steer would be hogtied, and the brand examined. We would shave the hair to read the brand, and when Russell named a brand he was never wrong.

The cowboys were sitting around the camp fire one night, talking race hoss, when Russell said, "Tuck has

a little Texas cow hoss that can run like hell." That started something. One evening late in June, I had a chance to race my Bunky hoss, and Charley and I won all the money the Shonkin boys had, sixty-two dollars, and Bunky won a rep.

On July third, old man Kingsbury, Joe Conway, Russell, and I were riding in the foothills of the Highwood Mountains, when Russell brought his cow hoss to a halt, and said, "Boys, I see buffalo."

We all stopped our hosses, and sure enough, Russell was right. Up one side of the mountain were seven buffalo nipping bunch grass.

There below them Russell, Kingsbury, and I had the big talk. Kingsbury said, "Tomorrow is the Fourth of July. If we could get those buffalo down to the round-up grounds the boys could have a Wild West show."

Russell had an idea: A bunch of cowboys were coming along the side of the mountain with a big bunch of cattle. Russell suggested that we ride up behind the buffalo and haze them into the cattle. Did we do it? We did it so nice and easy we drove the entire bunch of buffalo in with the cattle to the round-up grounds. There were three thousand longhorns on the ground when we got there. The cattle king told the round-up captain our plans, so the captain didn't have us do any branding that night. He didn't want to scare the buffalo. He put on an extra bunch of night herders, and in the morning we still had all the buffalo. We got up early, the morning of the Fourth, because we were planning one big time roping the buffalo and tying them down.

The captain of the round-up picked fourteen good ropers. A pair of cowboys were to work together. I was one of the lucky ones, so I chose my pal Charley Russell to work with me. I was to catch the buffalo around the neck with my las' rope, and Charley was to catch him by the hind feet. I put the leather on my Bunky hoss. He was the fastest hoss in the Northwest, and I was a light rider. Charley and I rode side by side to the cow herd. The buffalo were in the center of the herd.

I took the rawhide off my saddle. I had made this lariat myself and it was a good one. As we came close the buffalo bolted out of the herd, with Russell and me and a bunch of wild cowboys whooping and yelling like Sioux Indians behind them. They went down a long slope. I singled out a big four-year-old bull. The other six buffaloes were cows and calves.

Don't let anyone tell you a buffalo can't run. A buffalo can outrun any common hoss. But Bunky was no common hoss. He had run buffalo before, and he ran this old monarch of the plains over a mile. We were gaining on Mister Bull. Just before I dropped my rope on old buf' I looked back to see if Russell was coming. He was coming, all right, but he was a quarter of a mile behind me. He was 'way ahead of the other cowboys, at that.

The buffalo was going down grade. The bull couldn't run as fast as the cows and calves. I hooked my spurs into Bunky's belly, and took two swings around my head with my rawhide rope, and made a long shot. The loop slipped over the bull's woolly head, and he stepped into the loop with one front leg.

I took my turns around the horn of my old Texas saddle. The bull didn't stop. He bowed his neck and made a big bawl. Bunky was pawing the bunch grass with his hind feet, doing his best to hold the raging, bawling buffalo. That bull dragged my poor Texas race hoss thirty feet, and Bunky was beginning to wilt. My hoss was about to go end over end. I took the turns off my saddle horn, and saved my hoss and myself from a big spill. I made the buffalo bull a present of my prize rawhide rope.

Bunky and I looked on in disgust, watching him take my las' rope over the rimrock. Russell came up, his hoss foaming. He said nothing, and I was too mad to talk. He rode over to the rimrock where the buffalo had jumped off. The bull had swam the Missouri River. He got out of the water, shook himself, and trailed up the opposite bank with my rope wriggling like a snake in the grass behind him.

Russell spoke first. "Don't cry, Tuck. I'll help you build another rawhide rope next winter."

I had roped buffalo calves and dragged them into camp, but never before had I had my twine on a buffalo bull. Charley and I were in Fort Benton, once, when the "Diamond R" freight outfit pulled a buffalo bull into town. It had been shot a short distance from the Fort. We saw the old fellow weighed, and he pulled down twenty-one hundred pounds. There isn't a hoss alive that can hold a weight like that.

The Shonkin round-up finished its work May fifteenth. The last round-up was where the city of Great Falls now stands. Russell and I got word that there was

to be a big celebration in Fort Benton, July twentieth. Everyone in the North was going to be there — Indians, cowboys, Mounted Police from Fort McLeod, trappers, bullwhackers, mule skinners, stage drivers, and soldiers.

Charley said, "I came West to see everything, and I'm going to see that celebration."

"There's two of us, Charley," I said. "We'll trail for Fort Benton."

The steamboats "Silver City" and "Red Cloud" were bringing a lot of calico queens from St. Louis. A good-looking cowboy had a chance to win a wife at the big event, but Russell and I weren't looking for any sleeping dictionaries just yet. We weren't looking for calico, we were looking for excitement.

The captain of the Shonkin round-up had sporting blood in his veins. He ordered his cowboys, with three round-up wagons and cooks, to go to Benton and enjoy themselves.

We trailed to the old town to join in the big pow-wow — seventy-five strong, happy-go-lucky cowboys. When we got to the Missouri River we could look down on Fort Benton. Flags and banners were waving all over the old trading post. The "Silver City" and the "Red Cloud" were tied hard and fast to cottonwood trees, and the Red, White, and Blue was floating above their smokestacks.

All along the river in the cottonwoods were Indian tepees, and Indian ponies were feeding on the bunch grass that grew on the sidehills.

We boys trailed down the bluff single file, but the

wagons went round by the stage road. Old Mike Lynch was still running the ferry boat. As we came up he said, "Come on, boys, the old boat is free, today." Our hosses stepped on deck, and we were soon across the Missouri. We trailed through the willows, and parked our hosses on the dusty street.

Charley Green's father ran a saloon in Fort Benton. Charley was a cowboy. He looked after the cattle on the Shonkin range. He invited us all to his dad's place for a drink.

Old man Green gave us each a drink of good old Bourbon. Then the captain of the round-up bought one for the gang. After the cowboys had had a few drinks, they began to want to look pretty. They went in for Stetsons and black silk wipes and high-heeled boots, until they were dressed for anything that might come along.

Mr. Green wanted the cowboy artist to paint a picture for him, and in the morning Charley went to work. He finished the picture at noon. It was a picture of a cowboy riding a spinner. A spinner is the hardest hoss there is to ride, and cowboys fear him because he bucks and sunfishes. If he can't get his rider off that way, he twists and spins round. A boy that rides a spinner earns his prize money.

In the afternoon Charley Russell painted programs for the big events:

GRAND RIDING AND RACING CONTEST

CELEBRATING THE CLOSE OF THE JUDITH BASIN AND SHONKIN ROUND-UP

BUCKING CONTEST	$ 50
WILD HOSS RACING	$ 50
CALF ROPING	$ 25
STEER ROPING	$ 50
RELAY RACE	$100
COWBOY RACE	$ 50
SQUAW RELAY RACE	$ 25
INJUN BUCK RACE, ONE MILE	$ 25
WILD HOSS ROPING	$ 25
COW HOSS RACE, ONE-FOURTH MILE	$ 25
& SILVER-MOUNTED SADDLE WORTH	$200

TWO DOLLARS FEE TO ENTER ALL CONTESTS

The Committee in Charge Will Not Be Responsible for Accidents.

THE GRAND PARADE WILL START TOMORROW AT TEN O'CLOCK

HORACE BREWSTER, Manager

There were more white persons milling around Fort Benton the next morning than I had seen in one herd before in all my life. I had been in all the old cow towns, Abilene, Dodge City, Hayes City, Cheyenne, Miles City, and Billings, but I had never seen so many people together as there were that day in Fort Benton.

At sunrise there were fancy cowboys riding their prancing cow hosses up and down the dusty streets. Then would come a bunch of Indians all dolled up with their war bonnets on, the eagle feathers shivering in the morning breeze. The war ponies were decked in eagle feathers tied in their manes and tails. The Blackfeet and Piegans were in camp on the banks of the river. By eight o'clock the soldiers put in their appearance. They had fine hosses, but they didn't sit them just right. Their boots were blackened and shining. The Redcoats from across the line had good hosses. Most of the Canadians were ex-cowboys. There was a sprinkling of half-breed Indians in the crowds, and they were a dirty, lousy outfit. Everybody had his gun on his hip.

At ten o'clock, sharp, when the Red, White, and Blue rolled out to the wind from the big flagpole at the end of the street, the laughing cowboys rode by eight abreast. Most of these boys had been in the saddle from the time their mammies took their breechcloths off them, and the men who sat those parade hosses didn't fear God, man, or the devil.

Russell said this was the largest parade he had ever seen. The military band from Fort Assiniboine was

there, and made good music. They kept popping off at intervals all day.

The first night there was to be a big barbecue. Two six-year-old steers were to be scorched. A cowboy eats meat that has been scorched a little, then lops down raw likker, and the likker cooks the meat.

Before the barbecue came the Wild West show at two o'clock. It was held on the benchlands two miles from the old 'dobe fort. A band of wild hosses and a herd of wild longhorns were close herded near the half-mile track. There were no corrals or chutes for the hoss fighters to saddle their hosses in. Each man had to rope his wild hoss out of the hoss herd, hogtie him, put the hull on, and then get in the leather and ride him to a finish. The steer and calf ropers had to do all their work in the open.

There were twenty-five bucking hosses and twenty-five steer ropers in action at one time. Cowboys were yelling and whooping like demons, and Injuns were milling around in gaudy, wild costumes, putting on their war whoop. Once in a while a bronc fighter would get up from the ground with two handfuls of dirt, but by the time he got his bow legs straightened out he was sober.

That was the worst mixed herd I ever saw. There were leathery-faced cowboys craving action, thieving looking gamblers, sleepy-eyed half-breeds, big-eyed Chinamen, and brave Indian chiefs who were doing well to keep their young bucks from scalping somebody.

At four o'clock the quarter-mile race was set. My Bunky hoss was feeling like a blacktail deer, but he wasn't nervous. The cowboy artist bet his pile on my buckskin race hoss — one hundred twenty-seven dollars. The judge stretched a las' rope across the track. I pulled my hull off Bunky. Russell pulled my boots off, and I handed him my Stetson. Then I slipped on my hoss, and I knew that I would win.

I drew second place to the pole. Old man Green pulled the trigger, and the six race hosses made a standing start. The lasso rope was the mark. Bunky cut off the one hoss to the left and took the lead. The Injun hoss belonging to the Blackfeet ran side by side with Bunky, but coming down the home stretch Bunky's ears began to lie down. I lost my breath, and when I woke up my head was in Russell's lap, and I was sucking on a bottle of old Scotch. Charley had hold of my pulse. He said I would live. My hoss was standing close by with a brand-new saddle smothered all over with silver.

The Injun hoss was good, but not good enough. Russell told the boys, "I don't like to gamble, but when I do bet I always bet on the winning hoss."

Two dozen of my friends were sitting around me in the bunch grass, with enough money they had won to start a bank. Each man had a different idea of what we should do that night. Finally Russell took off his old Stetson, nice and easy, and laid it on the grass, adjusted his silk sash, and said, "All the virgins that have come up on the steamboat will be at the dance, and the dance will be at the new brick hotel at the end

of Main Street on the river bank. If any of you boys want a lady friend for life, to help you start a maverick ranch, now is your chance. They are all from my home town and are strictly religious."

We all looked as wise as pack rats.

After the big day was over we got our hosses and trailed down into the cottonwood trees where our camp was. The juice from the steer had put out the barbecue fire, and the round-up cook was taking his vacation. We took the saddles off our hosses, and the night wrangler did the rest. We found the cook's beer, two cases down by the river, and had scorched steer meat washed down with cold lager beer.

After we had smoked we had a medicine talk. Some of the boys wanted to go to the dance hall where the painted cats were, two dollars to get in and ten to get out. The high-toned cowboys wanted to go to the hotel dance. But Russell and I heard tom-toms down the river, and the Indians interested us most.

We trailed through the cottonwood trees to the Piegan camp. The Indians were circling the camp fire, jumping, and singing their war songs. Old bucks and young were raising the devil. They had nothing on but their breech-clouts. We watched those wild men enjoying themselves for two hours, and then went down the river half a mile to the Blackfeet camp.

The Blackfeet were dancing, eating, and fighting, and we didn't last long at their powwow. We trailed back to the heart of the city.

There were no "Extras" out, but we met old man Kingsbury and he told us the news: one young

cowpoke had fallen in love with a pretty gal at the brick hotel, but had crowded this love business too far and the girl had quit him cold. That made him mad, and he went gunning for somebody. The first person he met had been a Chinaman. He filled the Chinaman's breadbasket full of lead, and got on the wrong hoss and rode away, and nobody cares how far he goes.

Mr. Kingsbury wasn't in our class — he didn't drink — so Russell and I left him and milled around in the different places of amusement. We ran into Mike Lynch, and he was organized. He was so likkered up he couldn't walk, but was just feeling around.

Russell was tender-hearted. He said, "Tuck, let's take him home to his shack and put him to bed."

We carried and dragged him half a mile and put him to bed, and while we were bedding him down his wife gave us the devil for getting him drunk! As Charley was pulling off Mike's boots, Mike begged us not to leave him but to stay with him all night. It was midnight and we were tired, so Charley rolled in with old Mike and I bedded down on the soft side of the board floor. When day broke, and the morning star was looking over the top of the Highwood Mountains, I was sore from lying on the rough floor. The cowboy artist heard me moving around, and sat up and rubbed the alkali dust out of his eyes. He started to wake the Irishman, but the Irishman didn't wake. Charley called him by name, and I tried to give him an eye-opener from my bottle.

"Roll him over," I said.

He wouldn't roll. He was dead.

Charley stood up in bed and bumped his head on the ceiling, and hit the floor, his spurs jingling. He wasn't scared, but he looked queer. There we stood making eyes at each other.

Russell was the first to speak: "This is the first time I ever slept with a dead man."

The old lady had bedded down in the kitchen. She woke up, and rapped at our door: "Boys, have you got your clothes on?"

Charley told her we hadn't had them off. She stepped to the bed to wake Mike, but Mike couldn't talk. She took him by the arm, and right there Mrs. Lynch found she was a widow. She made the sign of the Cross, and stood looking at Mike, while big, honest tears rolled down her cheeks.

"Poor Mike," she said, "he liked his likker, and at last it got the best of him. Now the poor man's on me hands, a corpse."

She wiped her eyes on her calico apron, and said, "Mr. Tucker, will you please go for Father O'Reilly?"

Russell handed her the bottle, and she took a good drink. "This is going to be a hard blow on me, b'ys," she said.

I went for the priest. He lived in a 'dobe shack. I rapped loud on his door. The kind old Father asked me in, and gave me a stool to sit on.

"Is there anything wrong?" he asked.

"Mr. Lynch is dead."

"Did anyone slay him?"

"No, he died in bed, last night, after Charley and I took him home."

"That was his great trouble. He drank too much. Go back, and tell Mrs. Lynch that I will be down at eight o'clock."

On my way back I stopped at John Green's saloon to tell the bad news. Mr. Green said Mike had it coming. He gave me a drink, and told me to tend bar while he hunted up some women to go down to Mrs. Lynch's.

When Mr. Green came back I went on to Mrs. Lynch's to get Russell. The house was full of women, crying and boohooing. I got Charley and we trailed to camp. Mike Ryan was up, and had the Java boiling and the flapjacks cooking. He made us a cafe royal. Mike was Irish, and felt sorry for Mrs. Lynch.

Poor old Mike Lynch had lots of friends, Indians included. After breakfast, Ryan, Charley, and I went to the house again, and met Father O'Reilly. He asked us to fix Mike up for burial. Russell and I washed and shaved him, and he looked decent. I cut Mike's chin, a little, shaving him, and that night I dreamed he was giving me hell for cutting him. I never shaved another dead man.

We laid poor Mike away on the hill.

We spent three days at Fort Benton, and had a rollicking time. Quite a few of the boys got married in the excitement.

The night of the third day we ran into Mr. Kingsbury with a man named Charles Dolan. Mr. Kingsbury introduced Mr. Dolan, and told us Dolan had bought

twelve hundred head of stock cattle, and wanted someone to trail them down to the Red Water range.

Charley and I took the contract. Dolan was to furnish the groceries and all the saddle hosses.

We rounded up five old cowpokes who were broke and glad to go to work. The cattle were at Sun River Crossing. We settled up with Captain Horace Brewster, gave back the cow hosses that belonged to the Judith Basin Round-up Association, and told him we had a big contract. Mr. Dolan bought a four-hoss outfit, and a wagon load of groceries.

We hired Old Dutchy for trail cook. He was a dirty cook, but he was the best we could get, and he savvied four-hosses.

When we were ready to start Charley and I put our bed rolls in the grub wagon, and Mr. Dolan rode with the cook. We camped one night at Antelope Springs.

A big freight outfit was there when we drove up, and there seemed to be excitement and confusion. One of their wagon tongues was sticking straight up, and they were getting ready to hang Bob Smith for stealing. He had stolen four hundred dollars from the wagon boss. The wagon boss kept this money in an extra pair of boots. Bob, a mule skinner, found the boots and took the money, and refused to tell where he had hidden it. When they got the rope around his neck and started to pull him up on the wagon tongue, Bob confessed and told where the money was.

They kicked him out of camp, and he hit the trail talking to himself.

Russell saw him three years afterwards, hanging in

a cottonwood tree on Milk River. Russell said he had stolen a rope with a hoss on the end of it.

On July 25, 1884, Russell and I started Dolan's herd for the Red Water range. There were no trails, but we knew the landmarks. It was the same old story: when the cook dug into the grub wagon he found a lot of rusty government bacon. We cowboys didn't eat bacon when we were driving cattle. We didn't say anything to Mr. Dolan, but the first night on the trail when we started to bed the cattle down Russell dropped his loop on a fat bull calf and dragged it to camp.

Mr. Dolan stepped out and wanted to know what was the matter with the calf, and Russell told him it had the blackleg.

"Will he be good to eat?" Dolan asked.

"Sure," Russell answered the pilgrim cowman.

He winked at the cook, and we didn't eat any bacon on this long trail, but we ate five calves. There was plenty of antelope in this country, so we had fresh meat and a change from beef.

13

New Range

THE THIRD DAY on the trail brought us into the Judith Basin country. Going through the basin we had lots of trouble with the range bulls. We had to rope and hogtie them, and let them lie on the bunch grass until the herd got out of sight. When a cowboy detailed to handle a bull finally let him up, he was glad to go back where he belonged.

Dropping down on Flatwillow Creek out of Snowy Mountain Pass we met Billy Page, a friend of ours, and put him on the payroll. Billy savvied cows. We tied a can to Sleepy Joe, and he went off talking to himself. He was too lazy to punch cows.

We trailed along nice and easy until we got to Miles City, but there we ran into excitement. The whole range was in an uproar, with wild-eyed shooting cowboys combing the Bad Lands of the Missouri for three half-breeds who had kidnapped two white girls. The breeds had stolen them from their dad's homestead on Pumpkin Creek, a short distance out of Miles City.

We were in sympathy with the Vigilantes, so we gave our trail herd a rest. Dolan and I and two other cowpokes close herded the cattle, and Charley Erickson, Injun Charley, Billy Page, and Charley Russell joined the man-hunters.

Injun Charley was hell on a trail, and the boys stayed with him. They were riding fools. They located the kidnappers on the Missouri River about dark.

Russell told me they found the half-breeds camped in willows close to the river. He and Injun Charley got off their hosses, and crawled on their hands and knees until they could look into the kidnappers' camp. The girls were unharmed, but their feet were tied.

The breeds were drunk. While Russell and Injun Charley were crawling up on the half-breeds, Billy Page and Erickson stayed back with the hosses. They saw ten more cowboys riding toward them up the river. Billy stopped them, and told them the boys had located the kidnappers. The whole bunch waited for Russell and Injun to come back and report, then one man stayed with the hosses and the others surrounded the kidnappers. Our men took the breeds by surprise, and held a kangaroo court that didn't last long. In a few minutes the half-breeds were looking through cottonwood leaves.

The cowboys and the rescued girls camped at the mouth of Rattlesnake Creek that night. The girls were pretty badly scratched up, but otherwise they were all right. On the fourth day the boys got back to Miles City, and Injun Charley was the hero of the Yellowstone. He camped with us one night, and then

took the girls back to their home on Pumpkin Creek. This was the last excitement on the trail.

On September tenth we landed at Charley Dolan's ranch on Red Water. We branded the calves and turned the herd loose, and camped with Mr. Dolan three days. He was sick of the cattle business and wanted to turn the outfit over to Russell and me, but we had other plans. Charley was going to St. Louis to winter with his mammy, and I was going to Chicago to see an old aunt I hadn't seen for twenty years. She was married to a man in the commission business who bought and sold cattle. On the third day we rolled our beds, sewed our saddles in gunny sacks, and were ready to trail back to the States. Mr. Dolan was going to Boston, and said he would travel with Russell and me. He put Charley Erickson in as foreman of his cow ranch. We turned our private hosses over to Injun Charley to trail back to the Judith range with him. He had to go back, because he was married to a white wife there. When Charley would get tanked up on red likker and lie dead as a log, his wife would say, "I still love my Injun man." There was a buckboard at the Dolan ranch, and Charley Erickson took Mr. Dolan, Russell, and me to Glendive to catch the train.

We milled around Glendive for two days, and met a few old-timers that we knew. Mr. Dolan was buying the drinks, but we didn't drink much, just enough to have a good time. The third day we bought our tickets, stepped aboard the train, and took our seats on the cushions. We told Mr. Dolan the joke about the blackleg calves we ate on the trail. We told him any

time cowboys are trailing a bunch of cattle they aren't eating any sow-belly. He laughed, and we took another drink.

At St. Paul Russell told us he knew a place where we could eat two hours for two bits. He took the lead. My spurs were still buckled to my boots, and they made a lot of noise on the pavement. We traveled a block, and came to a big door that Charley held open for us. We stepped in, and all the little boys who had trailed us from the depot quit us at the door.

We were in front of a mahogany bar one hundred feet long, with a mirror behind it where you could see every freckle you had without trying. We took a good, modern feed, filling up on pigs' feet, rye bread, and lager beer. Mr. Dolan paid the bill, six bits.

We went out to the street, Russell in the lead, because we didn't know this range and he did. He was trailing us to a high-toned bunkhouse where we could bed down.

Just as we turned the corner of a brick tepee we bumped into Bill Cameron, the sheriff of our home range. He was in St. Paul on legal business. He told us he was camped at the King Hotel, and invited us to his room. He and Russell took the lead, and Mr. Dolan and I trailed behind. When we got to the old log hotel, the Montana sheriff introduced us to the landlord, Mr. King. He didn't have any crown, but he was holding down the throne, with a big feather stuck behind his ear for a penholder.

In Bill's room we all bogged down on Bill's bunk. The cowboy artist began to make eyes at Bill. He said,

"Bill, where is that bottle?" The old Injun fighter reached under his bunk and pulled out the bottle.

While we were enjoying ourselves, I told a secret: I had a diamond ring that I had picked up on the dance hall floor at Fort Benton, long before. Some painted cat must have dropped it while she was milling around the floor with a drunken cowboy. I showed my diamond to my friends and asked them how much it was worth, but they didn't know any more about diamonds than I did.

Russell told me to take the ring to a pawn shop and see what they offered. The old sheriff pulled the cork out of the bottle, we all took a drink, and went down to the lobby of the hotel where my friends were to wait for me until I came back.

I slipped out to the street, and a block from the hotel stepped into a shop. The Jew behind the counter had only one eye, but he could see more with that one than I could with my two. I showed him the ring and told him I was hard up and wanted to know how much I could borrow on it. He began to lick his lips like a Chessy cat, and looked the ring over hard. He offered me twenty-five bucks. Then I knew I had a good ring to give to my old aunt in Chicago. I told him to give me back my ring, and he raised his offer to thirty dollars. Then I knew I had a real ring.

I took my ring and headed back toward the King Hotel, but I didn't go far. A big bull policeman grabbed me by the arm: "Come with me, you diamond thief!"

He led me down the street, with natives trailing

behind me. At the hotel the Montana sheriff came to my rescue. He grabbed the Irish bull by the shoulder and told him to explain himself. The natives milled around, talking to each other: "Ain't he a tough looking bugger? See, a policeman and sheriff have got him!" They kept popping off about how I looked and how tough I was.

The policeman told Bill Cameron I was a robber, and pointed to my gat.

"Look at that!" he said. "Look at that six-shooter he is carrying!" The little boys nudged each other and said, "I betcha he's killed lots of people with that!"

Russell and Mr. Dolan and the sheriff went with me to headquarters, and I had to pay fifty dollars for carrying concealed weapons. Old Cameron squared me with the judge about the diamond, though.

Russell was to take the midnight train for St. Louis. It was agreed between us that I was to visit him in St. Louis, and be there October fifteenth. He gave me his father's address. The train pulled in, he shook hands with each of us, stepped on, and was gone.

The next day Mr. Dolan and I went to Chicago. He wanted me to go to Boston with him, but I told him I must see my old aunt. We prowled around the city until midnight. Mr. Dolan's folks had more money than some folks have hay and straw, and he spent his money freely. He left, the next morning, for Boston.

I was a stranger and I didn't know the range, but I knew my aunt lived way out on the shore of Lake Michigan. Her number was five hundred three. I hired a native with a hack to take me to her shack. He found the place, and I stepped out of this one-hoss bus and

gave the driver a dollar. I walked up the steps of the porch, and opened the door. I didn't rap, because it was my auntie's house. A young woman met me. She looked wild at me, and shut the door. I opened the door again, but this time there was another woman in the room. She was grey-haired, and looked ready to fight.

I stepped in and closed the door.

"Open that door behind you and get out of here, you dirty tramp!" she said.

This tickled me all over. I said I had come to stay. We looked and looked at each other, and the more I looked the bigger she got, and the first I knew I was in her arms.

"You can't fool me," she said. "You look like your dad!"

My cousin came in. She was a shy young school-ma'am, very refined and religious. My aunt asked about my trunk, and said Annie must go with me to get it — for all travelers have trunks. My cousin and I got on the street car to go after my saddle and old greasy war bag. I had checked them at the depot. We didn't go to the depot. We stayed on the street car and rode out to the Union stockyards. Here I saw my uncle for the first time. He told me he was hatched out in Texas, and was an ex-cowboy. We got to be great friends. He had two old cow hosses that he used around the stockyards, so while I stayed in Chicago I wasn't afoot.

I took my silver-mounted saddle down to the yards, and helped my uncle cut out cattle.

One day a bunch of longhorns we were working

began to mill around in the high, board-fenced, square corral. They were wild, and milled into a corner. The posts were rotten, and the old longhorns pressed so hard the fence fell flat to the ground. The steers stampeded into a cabbage patch near the stockyards, where some Dutch women were gathering cabbage. There was a scattering among the Dutch! We got all the steers back but three, and these headed for the city. People were sitting on fences and climbing trees along the trail the old steers took. Policemen were shooting, but they were scared and shot high. They had buck fever.

One big brindle steer tangled up in a clothesline full of clothes, and I got my rope on him. My uncle roped one that was hooking a beer wagon. A third steer was trying to stop a street car. A team of hosses, running away, ran over this steer and hurt him so he couldn't get up. Three policemen filled him with lead.

There was plenty going on in Chicago, but it all looked tame to me. I longed to be where I belonged, away from dirty alleys, jammed streets, and starving children. I got up one morning with my mind made up to travel. I gave my old grey-haired aunt the diamond ring I had carried three years, kissed her good-by, and was on my way to St. Louis.

On the train I met a young fellow who wanted to know all about the West. He looked like a square shooter so I told him the truth. I told him about my friend, Charley Russell. As we came near St. Louis, he went back in another car where he said his mother was. He was gone about twenty minutes. While he was

gone the train came to a stop and two men got on. They came forward to the smoking car where I was resting easy, and walked up to me. One of them covered me with a six-gun, and the other showed a pair of steel cuffs. The one with the iron told me to stand up, and the other hobbled my hands. The conductor was standing close by, shivering till the buttons were ready to drop off his coat.

By this time the boy who had got acquainted with me out of Chicago stepped into the car. He wanted to know if there was anything he could do for me. I told him to get Charley Russell, when he got off at the station, and tell Charley I was arrested for one of the Jesse James gang.

I got off the train at St. Louis with handcuffs on, walking between two Pinkerton detectives. The natives milled around us like bees, telling each other I was a train robber.

"Look at his big white hat," one of them said.

The detectives were carrying my six-gun and belt, and I was obeying orders all the time.

They got me behind bars, all right. I was in jail two hours. Then I heard voices, and footsteps coming closer and closer to my corral. I couldn't see anybody, but I could hear my old pal Charley Russell talking.

The jailor turned on the light and unlocked the big iron door, and Charley stepped in and gave me an introduction to his dad. His father was a prominent man in St. Louis, and president of the St. Louis Pressed Brick Company. He went my bail, and the big bull took my hobbles off and turned me loose.

Charley wanted to know all about it, and I said, "This is a hell of a range to live in — fifty bucks for carrying a gun, and now forty bucks more for carrying it! Old pal, I'm lasting quick on your range."

I camped with Charley one moon. His mammy was a good old southern mammy, and dearly loved her boy. Charley showed me a good time in St. Louis, but I wasn't satisfied. I wanted to be out, away from crowded streets and the smells of dirty barrooms, away from fried shirts and paper collars and straw hats. I was headed for Texas. I wanted the old range, and I knew Charley wanted to go with me and would start if I said the word.

His mammy was worried. She came to me one night and said she felt sure we were planning to leave, and she didn't want Charley to go with me. She told me all the plans she had for him. She wanted him to study, so he could be a real artist. She wanted him to go east.

I could see how much this meant to her. I could see that maybe it would be best for Charley. Anyway there was no way I could tell her it wouldn't. She said she wanted me to leave in the morning, early; to leave without telling Charley I was going.

I told her I couldn't do that, and she said she wanted me to go without telling Charley she had talked to me.

That night Charley seemed to know something was up. He said he was going to bunk with me. I told him I didn't want anybody bunking with me, and he went back to his own room. I think he knew, but he didn't say anything.

The train left the next morning about five o'clock. I looked into Charley's room before I went, but he was asleep — at least his head was turned away. I didn't wake him.

When I got to Texas I began peddling hosses for my old boss, Colonel Head. He handled hosses by the thousands, and had contracts all over the West and Old Mexico. That was the way I got my groceries.

I smelled like a hoss for nine years. Then I got married. I told my boss I wanted a lay-off. "How long do you want to lay off?" he asked, and I answered, "For ninety-nine years."

I tied my saddle in a gunny sack with a buckskin string, and bought me a one-way ticket to the end of the railroad — Great Falls, Montana.

At Denver, while I was waiting on the platform for the train to pull in, I ran across George Shannon. Shannon was a big commission man in Chicago. He told me he still had cattle in Montana, running in the Judith Basin. He wanted me to gather all his range cattle, and ship them to the Shannon brothers, George and John, in Chicago. He gave me a contract for the work while we talked between trains.

The Shannon brand was a cross-hack on the left rib.

When the train pulled in I shook hands with Mr. Shannon, stepped aboard, went to the sleeping car, and bedded down. I was dreaming of punching cows once more.

At Great Falls I bought two hosses, and trailed to the Judith Basin. I was glad to get back to the long

grass country once more. I took the old pack trail to the Basin. The second day out I was trailing across Rocky Ridge toward Arrow Creek, when I saw dust in the distance. Pretty soon I could make out a lone rider.

At Arrow Creek I stopped, took the pack off my pack hoss, and soon had the Java boiling. My hosses were grazing close by. They quit eating bunch grass, and looked up at the trail. I looked where they were looking, and saw my old pal, Charley Russell.

What we talked about will never be in print. I asked Charley to help me round up the Cross-Hack cattle, but he said he was through punching cows. He was going to take up a homestead in Great Falls, and paint pictures.

We camped that night on Arrow Creek, and bedded down together. We didn't sleep much. I told Charley that I was married—my wife was still down south waiting for me to send for her.

The next morning I cooked chow while Charley got the hosses. After breakfast we had the big smoke, and then packed our hosses. Charley took my hand, and we said good-by. We got on our hosses and went our different ways. Almost the next thing I knew of Charley, he was married. His being married didn't spoil our friendship, we were pals to the end; but things were different.

Charley Russell had more friends than any other man I have known. He couldn't stand quarreling or trouble of any kind between men. He would go to any

length to straighten out a misunderstanding. If anyone did him an injury he always insisted they didn't mean it that way, and hadn't figured how what they did would turn out. He cared nothing for money when he rode the range, and had no use for it except to give his friends a good time. He became wealthy and he became famous, and knew important people, but he always liked his old friends best.

For us who knew him the range has never been the same since Charley went over the Divide.

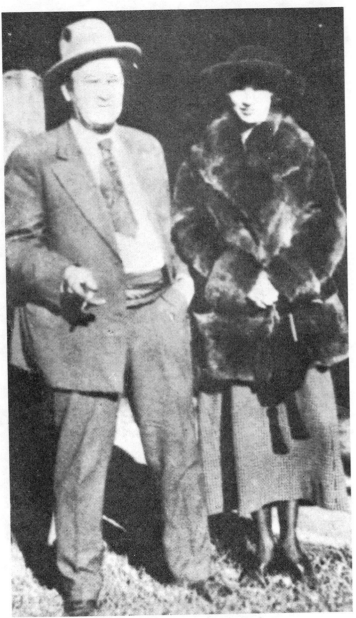

Charles M. Russell and Mary Tucker